P A S T E L

for the SERIOUS BEGINNER

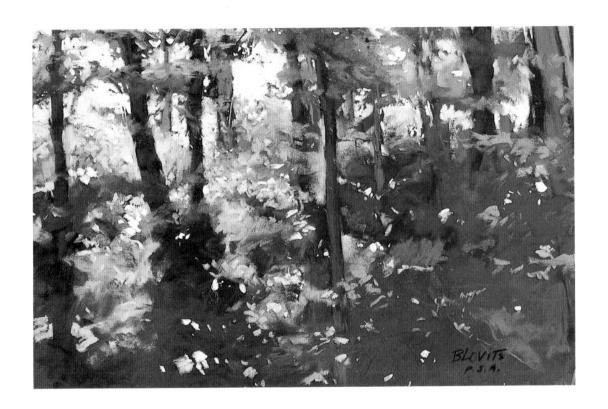

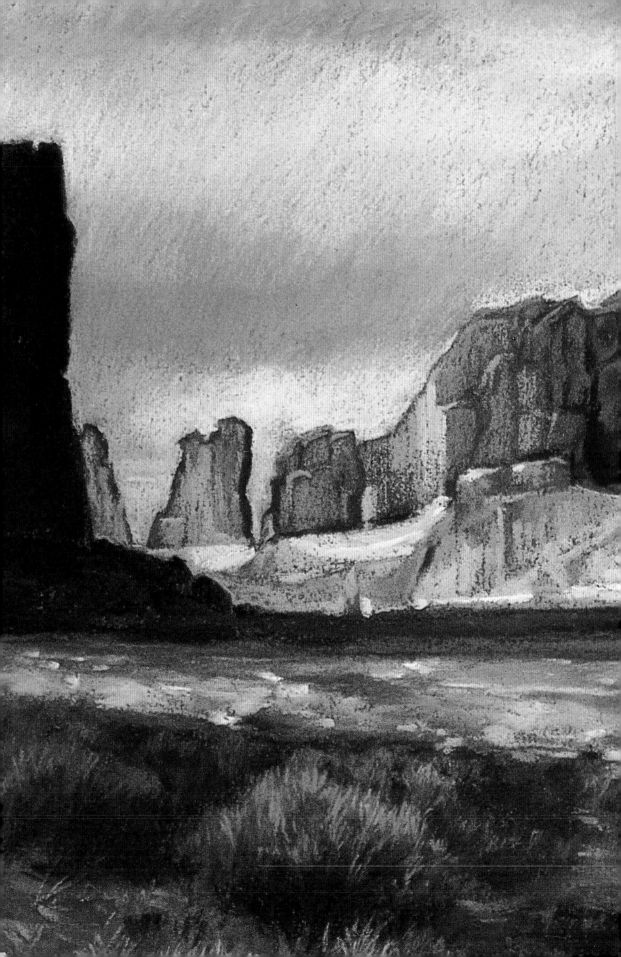

PASTEL

for the SERIOUS BEGINNER

Larry Blovits

WATSON-GUPTILL PUBLICATIONS/NEW YORK

I DEDICATE THIS BOOK TO MY MOTHER AND ELDEST BROTHER, TOM, WHO DIED TOO EARLY;
TO BROTHERS JIM AND JEFF AND SISTER DEE, WHO PROVIDE ME WITH THE LOVE AND SUPPORT I ALWAYS NEED;
TO MY KIDS, LAURI, LISA, JAY, JACK, AND GREG, WHO HAVE ENDURED AN ARTIST FOR A FATHER;
AND TO LINDA, WHO MAKES MY DAYS BRIGHT AND WONDERFUL.

Frontispiece:
INTERPLAY
Pastel on paper, 8 × 10" (20.3 × 25.4 cm).
Collection of the artist.

Title page:
ARCHES NATIONAL PARK, UTAH
Pastel on paper, 10 × 14" (25.4 × 34.6 cm).
Collection of Brenda Mattson.

Edited by Robbie Capp
Designed by Areta Buk
Graphic production by Ellen Greene
Text set in Adobe Garamond

Copyright © 1996 Larry Blovits

First published in 1996 in the United States by
Watson-Guptill Publications,
a division of VNU Business Media, Inc.,
770 Broadway, New York, NY 10003
www.watsonguptill.com

Library of Congress Cataloging-in-Publication Data

Blovits, Larry.
 Pastel for the serious beginner / Larry Blovits.
 p. cm.
 Includes index.
 ISBN 0-8230-3907-2 (pbk. : alk. paper)
 1. Pastel drawing—Technique. I. Title.
NC880.B57 1996
741.2'35—DC20 96-27501
 CIP

Manufactured in Hong Kong

First printing, 1996

7 8 / 03

About the Author

Larry Blovits has been immersed in art for all of
his adult life. After receiving a bachelor's degree
(1964) and master of fine arts degree (1966)
from Wayne State University, Detroit, he went
on to become a college professor (now retired),
workshop instructor, and professional artist.

Widely known over the past thirty years for
landscape and portrait paintings, he has won
numerous awards and exhibition honors. His
work is represented in collections throughout
the United States and abroad, and includes
portrait commissions of senators, university and
corporation presidents, and other prominent
members of the academic, business, legal, and
religious communities.

His professional honors include the title
Master Pastelist, awarded by the Pastel Society of
America, and signature status in other prestigious
art associations: Knickerbocker Artists,
Salmagundi Club, American Portrait Society,
and the American Society of Portrait Artists.

The cover artist for *Pastel Interpretations*
(North Light, 1993) and one of eighteen
artists represented in that book, Blovits is also
represented in three other art volumes: *The Art
of Pastel Portraiture* (Watson-Guptill, 1996);
Fresh Flowers: The Best of Floral Painting (North
Light, 1996); and the *Directory of American
Portrait Artists* (American Portrait Society,
1985). His unusually designed residence/studio
in Grand Rapids, Michigan, was featured in
a six-page article in the June 1990 issue of
American Artist.

Contents

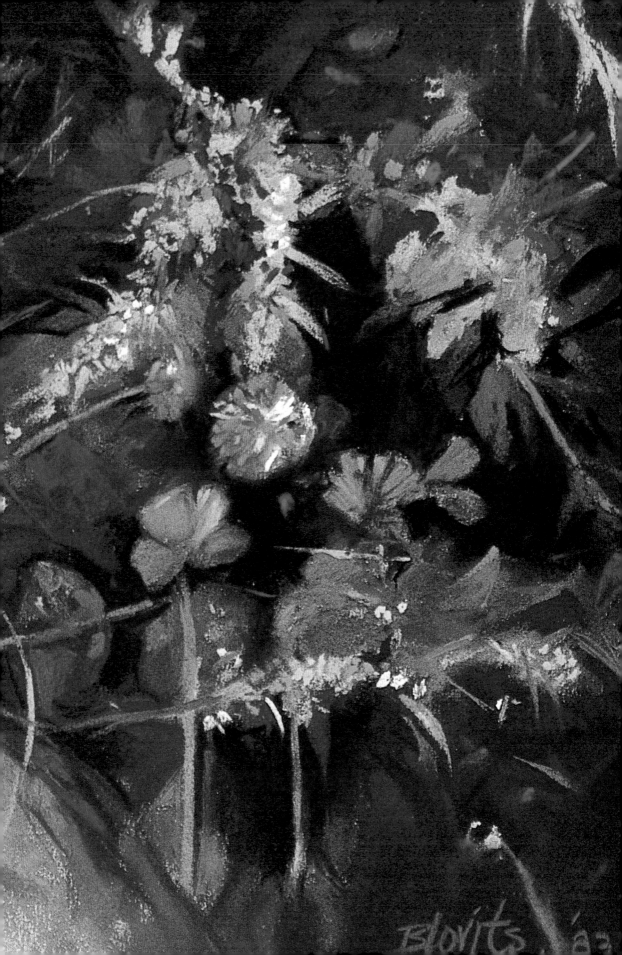

Introduction

As a teacher of art and professional painter for more than three decades, I've drawn on my experience in both arenas in preparing material for this book. Pastel art is my particular passion. I value the teachings of the great masters of art and base my pastel work and instruction on their guidelines for creating illusions of light, volume, and depth. The years have matured my views and developed my application of those principles to pastel art, which I hope to convey to you through this book.

That you have chosen to approach pastel painting as a serious beginner makes my job as teacher a very gratifying one. In speaking to someone who really wants to learn how to use pastels, I believe that starting with the basics is what you want and need to know to work in this medium, so that's where we'll begin—by discussing pastel materials themselves. Then we'll move on to fundamentals of pastel color, mixing, application techniques as they specifically relate first to still-life, then to landscapes, and finally to portrait painting—with step-by-step illustrated demonstrations to guide you.

All it takes from you is the willingness to try, to fail (because that's how we learn), to enjoy experiencing the learning stages, and above all, to practice. Through practice, you will gain knowledge and insight into this beautiful art medium.

Happy pasteling!

SUNSWEPT (DETAIL)
Pastel on paper,
12 × 18" (30.5 × 45.7 cm).
Private collection.

This detail from the painting shown on page 99 illustrates the truly luscious color and tactile quality of the pastel medium.

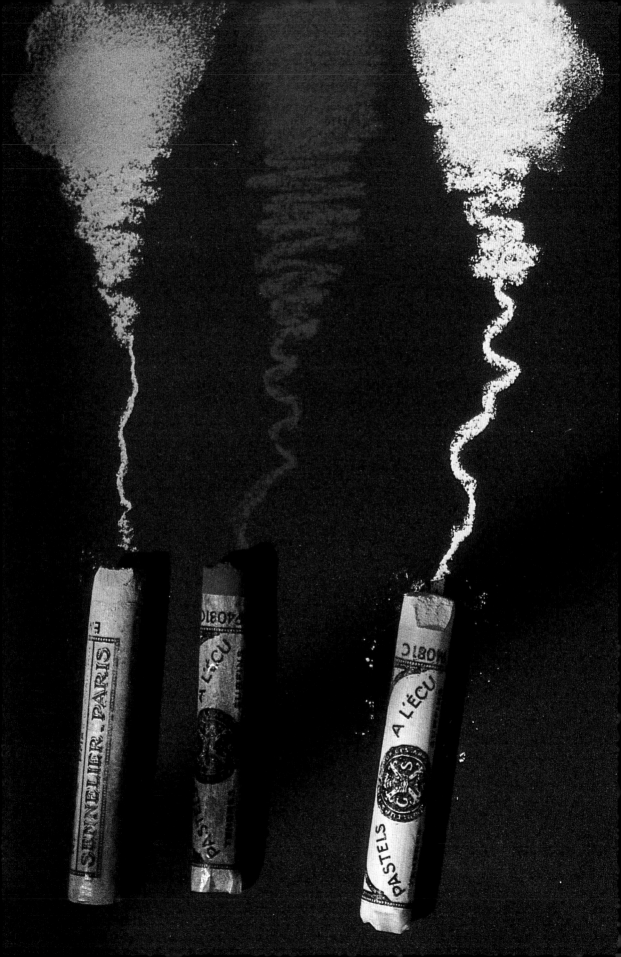

Materials

Artists who choose to work in pastels have a richer range of materials at their disposal today than ever before. But unlike many other painting mediums, pastel art actually requires very few supplies: just the pastels themselves, some paper or other support, and a few tools. This chapter will familiarize you with those basics, emphasizing the particular materials that I've used to create the pastel paintings shown throughout this book.

Pastels fall within three major categories: soft, hard, and pastel pencils. I favor traditional pastels in stick form, the form you're most likely to think of when you hear the word *pastel:* soft. Leading pastel brands will be discussed in this chapter.

Supports—paper and other surfaces on which pastelists work—come next. If you're trying this medium for the first time, you may be surprised to find just how much surface texture can contribute to the look of a pastel painting. Discover for yourself by experimenting with various surfaces as you develop your personal pastel technique.

Given the dusty nature of soft pastel, fixatives are used both during the painting process and as a final step to protect your work from smears. Recommended sprays and their safe application are reviewed. Various mediums used by pastelists are covered next, as are tools for blending, erasing, and holding pastels. This chapter also offers tips on setting up your workspace and organizing your pastel palette.

Finally, as a serious beginner, you'll certainly want to preserve your pastel paintings, not just to keep track of your development as your skills and confidence grow, but also to delight friends and family with personal gifts of your work. With this in mind, I've included information about caring for finished work—matting, framing, and storing. Such guidance will be particularly helpful to the reader—and that might be *you*—who takes the next step: going from serious beginner to professional pastel artist.

Three of the more than five hundred luminous colors made by Sennelier, the respected French firm whose excellent soft pastels have been delighting artists since 1887.

Pastels

Pastel is a stick of pure pigment, plus precipitated chalk, held together by a binder, gum tragacanth. (Oil paints and watercolors are made from the same raw pigments, but with different binders.) The amount of binder determines the hardness or softness of the pastel; the harder the pastel, the more binder has been added; the softer, the less binder. Pastels never dry up, or become "old" and unusable.

Pastel marks differ depending on whether the stick is hard, medium, or soft, economical or expensive. Very inexpensive pastel sets contain more filler and less pure pigment in their makeup, and my best advice is not to use them at all.

SOFT PASTELS

Best for building color and texture, soft pastels come in sets of sticks (cylindrical or flat-edged, 2–6" long, or 5–15 cm), bare or covered in removable wrappers. Certain sets, such as those made by Schmincke and Sennelier, two leading manufacturers, are more saturated in color than less expensive pastels. Both come in gorgeous and extensive ranges of colors. Other fine brands are Grumbacher, Rembrandt,

Rowney, and Quentin de la Tour (Girault). The consistency of the latter is actually somewhere between soft and hard.

HARD PASTELS

In stick or pencil form, hard pastels can be applied alone or in combination with soft pastels. They are useful as drawing tools and for fine-line details. Manufacturers include NuPastel and Holbein, both popular, inexpensive, and widely distributed lines. A full range of NuPastels is a fine set to begin with and can be intermixed with any other brand of top-quality pastels purchased in the future.

OIL PASTELS AND OIL STICKS

Unlike chalk pastels, known for centuries, these newer forms came on the scene only a few decades ago. Completely dustless, they have a crayonlike texture, and perform more like oil paints than soft pastels. While the work and instruction in these pages concentrates on soft pastel, oil pastels and oil sticks are tools that you may want to explore to broaden your creative options and expression.

Some of the many sets of pastels offered by fine manufacturers. Single sticks can be purchased to replace or augment colors that come in sets.

Supports and Surfaces

Pastel surfaces come in several forms: paper, sanded pastel paper, pastel canvas, and board. Since pastel is a dry medium, it requires a ground with a somewhat rough surface or "tooth" (its peaks and valleys) to hold the pastel. The look of a finished pastel painting is definitely contingent upon its support, including its texture (how rough or smooth); its tone (ranging from light to dark); and its color (warm, cool, or neutral). Each surface responds to create its own unique look, and the artist must adjust pastel strokes and blends accordingly. Professionals are constantly switching to different surfaces or creating their own, learning each support's characteristics and how best to work with it. I encourage beginners to experiment in the same way.

PAPER

Every paper surface has texture as one of its properties, ranging from very smooth to very rough, but some papers are more suitable for permanent painting than others. The serious pastel artist should seek out a permanent or archival paper that can hold up to revisions and reworking. Although inexpensive papers (such as manila and newsprint) are a bargain and useful for practice and experimentation, they have a tendency to age, crack, turn different colors, and bleach out when exposed to sunlight. Therefore, they are not recommended for permanent pastel painting.

Pastel Paper

The beginner should choose a surface that's easy to use and can withstand numerous revisions and corrections. For the serious beginner, I recommend the classic French pastel paper Canson Mi-Teintes, which satisfies those requirements. It comes in fifty-one colors, available in sheets, rolls, pads, and fine-art boards. For both economy and quality, I suggest that you buy paper in bulk (at least ten sheets), if possible from a discount art supply warehouse for the best break in price (usually at half the cost of an individual sheet purchased from the neighborhood art store), and start with a subtle neutral color such as #431 Steel Gray, #354 Sky Blue, or #426 Moonstone. Standard-size sheets measure approximately 19 × 25" (50 × 60 cm).

Canson Mi-Teintes paper has two distinctly different sides: a "wire" side (with a definite pattern and readable watermark or name embossed along one edge); and a soft side, having a smooth, blotterlike surface. Contrary to what other artists may recommend, I prefer the soft side because it holds more pastel, and you don't have to constantly fight the dominant characteristics of the machine-made pattern found on the wire side. Its rough-looking texture (like a window screen) will permeate every stroke you put down, demanding the viewer's attention and often making the texture more visually important than the image itself. In essence, a rough texture is always competing with subject matter, tends to dominate the statement, and makes visual clarity, marks, and spatial illusions almost impossible to achieve and see. The softer, blotterlike reverse side holds more pastel, is easier to work with, and is much more receptive to marks and images the artist wants to create and control.

Canson paper will accept numerous layers, using the following procedure: Snapping fingertips against the paper surface unclogs the paper's pores, making

Choices of Canson Mi-Teintes paper, a brand I prefer to use, most often in a neutral gray, rarely in white.

A definite paper pattern shows through pastel on the wire side of Canson Mi-Teintes paper.

it ready to accept more pastel. The artist can then continue to add as many layers or corrections as needed. Placing additional layers of paper under the Canson paper will soften the blow, and also will make the surface more receptive to a variety of marks that can't be made on a "hard" surface. (This technique will not work with sanded papers, discussed below.)

Other well-known makers of pastel paper in a wide variety of textures and weights include Crescent, Daler-Rowney, Fabriano, Lana, and Strathmore.

Charcoal Paper

Available in both white and colors, paper made for charcoal drawings can also be used for pastel work, though it is usually lighter in weight. Brands include Canson, Strathmore, Gainsborough, and Michelangelo.

Sanded and Coated Pastel Papers

Another surface currently in favor with pastelists is sanded pastel paper, which is available with a 500- (rougher) or 700- (smoother) grit surface and can be purchased in sheets or rolls. Sanded paper is a little more restrictive and less forgiving for the beginner to use but certainly is a viable surface for more experienced artists. Once the fine "tooth" has been filled with pastel (after three or four layers), the sandpaper surface will not hold or accept additional pastel, unless it's very soft, such as Schmincke or Sennelier pastel. Spraying the surface with a workable fixative—to isolate previous layers and create a new tooth able to hold additional pastel applications—is a possible solution to this problem.

Sanded paper tenaciously holds the pastel, and very little, if any, pastel dust is dislodged from the surface during handling. One of my pastel paintings on sanded paper was sent to an exhibition in Paris

and required no cleaning when it was shipped back to me. Canson Mi-Teintes paper doesn't exhibit the same degree of tenacity for shipping purposes and requires special handling.

Holbein's Sabertooth is a fine sanded paper. A new archival sandpaper made by Wallis is also an excellent choice. Another possibility is La Carte Pastel board, which has a slightly abrasive vegetable-fiber coating that makes it receptive to pastel.

PASTEL CLOTH

This newest support for pastel paintings comes only in rolls; it is cut to size and stretched over a wooden frame much like oil-painting canvas. Made of a vellumlike fabric and coated with white primer on the painting side, it seems to hold pastel very well, imparting a very soft, "painterly" image.

HOMEMADE AND OTHER SUPPORTS

Canvas boards and panels, mat boards, and wooden boards are some of the other myriad supports pastelists work on. Many artists experiment with making their own pastel surfaces; one such possibility is to combine, in equal amounts, a fine-grit stone such as pumice or marble dust with gesso and water. This mixture is then applied to a hard surface such as untempered Masonite. The amount of abrasive material in the mixture is crucial to the degree of texture desired; too much will create a surface similar to a rough file or rasp, using up pastels rapidly. Before applying the mixture to Masonite, first rough up the smooth surface with sandpaper (about 150 grit) for good adhesion. Never use the Masonite's rough-textured side. For additional information on ingredients and procedures for preparing textured surfaces, refer to *Pastel* by Daniel Greene and *The Pastel Book* by Bill Creevy, both published by Watson-Guptill.

Sabertooth pastel paper, made for Holbein and available in several colors, has a coating of sanded latex that takes pastel very well.

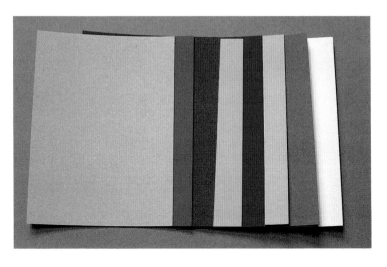

Fixatives and Mediums

Pastels can be enhanced and altered to achieve certain effects by adding fixatives and painting mediums.

WORKABLE FIXATIVES

In spray form, workable fixative is a clear, water-resistant protective coating formulated to prevent dusting and smudging. Its function is to temporarily isolate underlying layers of pastel from physically mixing with subsequently applied layers. If many different colors are mixed one into the other, a neutralized or dull color will result. Spraying the surface with fixative allows the artist to apply additional color on top of previous layers without this new color being sullied by intermixing with those that have already been put down. The pastel can be sprayed anytime *during* the development of the drawing; surfaces can be reworked anytime *after* spraying. However, it should be noted that most spray fixatives have a tendency to dull colors slightly, although this is usually perceived only by a very trained eye. For this reason, some artists prefer not to use any workable fixatives. To spray or not to spray is a personal decision of the artist. If you choose to experiment, among brands acceptable for use are Blair and Krylon. My personal choice is Lascaux-Fix, made in Switzerland, which I also use as my final spray. It doesn't seem to have the darkening properties I've found in other sprays.

A light spraying is adequate to hold pastel; be careful not to spray too long in one spot, or to apply too many layers. The former will result in a liquid state that will ruin the artwork; the latter may have a tendency to close the pores of the paper, setting up a slick surface that won't accept pastel. If this does happen, careful sanding with a fine-grit sandpaper can restore the needed tooth of the paper.

Always follow the manufacturer's instructions printed on the aerosol can, and spray only with adequate ventilation. If possible, spray outdoors rather than in your studio. Failure to pay attention to specific warnings printed on the spray can may result in serious health problems. Unfortunately, I know artists who have become ill after ignoring such warnings.

PERMANENT FIXATIVES

Even though pastel art is just about always framed behind glass, such protection still doesn't guarantee that pastel particles won't come off with rough handling. To prevent such damage, some artists use permanent fixatives in a final spraying to adhere pastel securely to the surface, before framing. However, permanent fixatives, such as Krylon's Crystal Clear, do not permit reworking, and some other final spray fixatives contain excess lacquer that darkens or completely eliminates certain light colors, especially whites. Therefore, I don't recommend their use with pastel, and that's why I use workable fixative as my final spray.

MEDIUMS

To make pastels more paintlike in application and create beautiful wash effects, especially for underpainting, solvents may be added. The most popular are gum turpentine (for soft pastels or oil pastels); alkyd painting medium (for oil pastels and sticks); and acrylic medium, which is water-soluble, as are pastels. Also note that since pastels are water-soluble, plain tap water may be brushed on to achieve a fine wash, but should be applied only to heavy papers or those that have been stretched (like watercolor papers). Isopropyl alcohol (rubbing alcohol) is another possibility, and offers the advantage of drying very quickly.

Tools

While you can get create a lovely painting using only pastels, paper, and fingers for blending, many tools are available to help you achieve more varied effects and to work more cleanly and efficiently.

BLENDING TOOLS

For making gradations of tone, a pencil-like cylinder of paper with pointed ends is used by some pastelists. I find these blending tools good for other mediums, but not practical for pastels. They usually dislodge the pastel from Canson paper, although they can be somewhat useful for sandpaper. Rubbed over pastel marks to blur and blend them, there are two tools of this kind: a tortillon, with long, thin ends for blurring fine lines and tiny details; and a blending stump, which has a shorter point for spreading pastels over larger areas. Chamois, soft rags, paper towels, and tissues are also suitable for pastel blending.

SHARPENERS

I use single-edged razor blades for sharpening soft and hard pastels. Sandpaper is another handy tool for this job, and a good desk pencil sharpener is best for pointing pastel pencils.

PASTEL HOLDERS

For soft pastels particularly, some artists rely on pastel holders, but I don't use them and don't recommend that you do. A holder has a plastic or metal cylinder into which the end of the pastel stick is inserted, thereby supposedly keeping fingers chalk-free, but I find that it does not, and that handling the pastel stick itself gives me greater control of application.

DRAWING BOARDS AND EASELS

You'll need a firm, even surface (such as hardwood, Plexiglas, Masonite, or Homosote) measuring at least 22 × 28" (56 × 71 cm) on which to mount the largest standard-size sheet of pastel paper (about 19 × 25"; 49 × 64 cm). Use drafting tape or clamps to hold your paper in place, and always place about six sheets of the same size paper under the one you're working on to cushion it and provide some resiliency so your surface will take pastel evenly. A soft surface will increase the variety of strokes you can make.

For studio work, choose a solid easel that adjusts vertically, tilts backward and forward, and has a top bar for bracing your drawing board. If you work outdoors, a folding French easel or lighter-weight portable aluminum model is most practical.

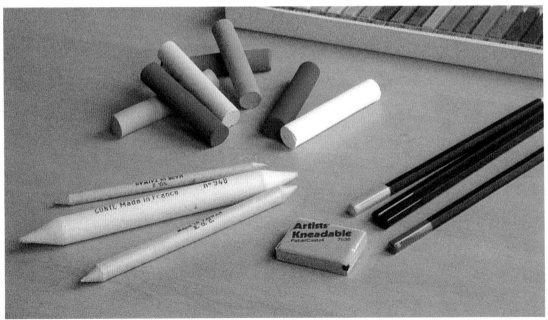

Tortillons (bottom left) are best used as blending tools only when you are working on a sandpaper surface. Soft pastels come in both flat-edged (in box, upper right) and round sticks. A kneaded eraser and pastel pencils are also part of the pastelist's basic tools.

Palette/Studio Setup

As a serious beginner in pastel painting, if you're lucky enough to have enough space to set aside an entire room for a studio, you're definitely in the minority. It's far more likely that the space you'll work in doubles as den, spare bedroom, or corner of the family room. So it's particularly important that your materials be neat, well organized, easy to set up, and conducive to getting right to work whenever your time and creative impulses take you to your easel.

ARRANGING YOUR PALETTE

Keeping your pastels in their original sets or boxes is not always advisable. Feel free to devise your own arrangement that allows you to find the desired color when you need it. The extra time spent searching for a color makes it difficult to remember the stick you originally wanted, why you needed it, and where you were going to use it in the first place. Newly purchased pastel sets are usually arranged in order of hue (following the color wheel) or value (lights, mediums, and darks). You may choose instead to group by warm and cool colors. So for future reference, after you've devised your palette, record the numbers found on wrappers or stamped on the pastel ends. Then, in case your pastels get out of order, the sticks can always be returned to their places for easier retrieval later on. If your sticks weren't packaged by the manufacturer according to hue or value, color by color in spectrum fashion, it's a good exercise to create such arrangements and build those lists, as well. As you use pastel, read each individual stick's label to become more familiar with the name of each color. After a while, you'll be able to recognize the name and pastel stick simultaneously.

MAINTENANCE OF PASTELS

Ongoing cleaning of pastels will help maintain their purity. The surface of a pastel stick gets dirty with the dust of colors transferred from fingertips and boxes, making it difficult to be sure what the true

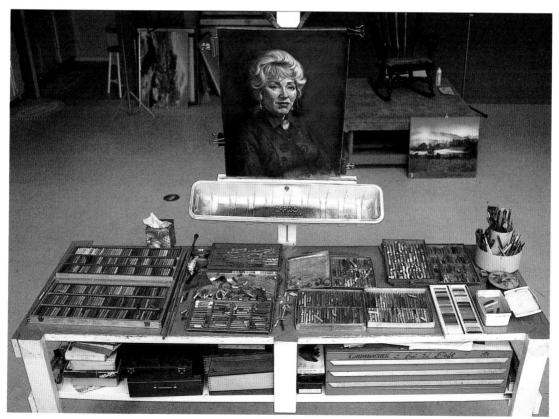

In the background above, you can see the platform and model's chair that I use for portrait work in my studio. The pan attached to my easel is placed there to catch the pastel particles that fall off during the process of working. This tray helps to keep my table surface and the pastels sitting on it clean. I vacuum the dust out of the tray periodically.

colors and values are. Periodically, I vacuum loose dust from my supply box, putting a soft screen cover over the end of the vacuum hose. Then with tissues or soft paper towels, I wipe soiled pastel sticks individually. Another cleansing method is to immerse soiled pastels in a box or jar of rice or cornmeal, sealing the container and then shaking it for two to five minutes. Pastel sticks will emerge clean, ready to be arranged in their proper order as described above. I also tissue-wipe pastel sticks as I use them; otherwise, the painting's surface color will be picked up by the stick on every application. Without cleaning, the artist returns a sullied color to the surface rather than a pure one.

Bottom line: If you want your paintings to sparkle, clean your pastels!

HEALTH CONSIDERATIONS

Some people are more sensitive than others to pastel dust. Artists who have a problem with it wear a mask or respirator and keep their hands covered with gloves or coated with a special cream or liquid that can be easily washed off. Experienced artists who make their own pastels definitely need to take such precautions. But for *all* pastelists, a general rule is to avoid inhaling pastel dust as much as possible, and to wash hands frequently during working hours. *Never* eat with soiled hands and risk ingesting pastel dust along with your doughnut. Vacuuming your palette table should be part of your ongoing work regimen. Routinely wiping nearby surfaces with a moist paper towel will keep your studio area clean and promote a safer working environment.

These Nu-Pastel sticks have been sharpened with a single-edged razor blade. This popular brand of hard pastels has a code number incised at the end of each stick, so colors can be easily referenced for replacement. This is a partial list of the nearly one hundred colors marketed by Nu-Pastel.

324	PLUM	224	VIOLET
346	BURGUNDY	254	HYACINTH VIO
353	CORDOVAN	304	ORCHID
363	GARNET	314	OLD LILAC
263		214	PERSIAN ROSE
223	BURNT UMBER	216	MAROON
283	VAN DYKE BROWN	234	RED-VIOLET
293	SEPIA	236	CARMINE
253	COCOA BROWN	256	CRIMSON
313	NUT BROWN	336	CARNIVAL REI
233	RAW SIENNA	206	CARMINE MAD
243	LIGHT OCHRE	246	ROSE PINK
273	TUSCAN RED	306	ORCHID PINK
213	SANGUINE	406	FLAMINGO
203	BURNT SIENNA	266	PALE VERMIL
343	RUST	226	SCARLET
383	CORAL	296	SALMON PINK
333	TITIAN BROWN	222	BURNT ORANG
416	DARK ROSE	212	DEEP ORANGE
316	OLD ROSE	207	DEEP CHROME
204	SANDLEWOOD	257	DEEP CADMIU
286	MADDER INK	227	CORN YELLOW
376	PEACH	217	LEMON YELLO
366	STEEL PEACH	276	FLESH PINK

Pastel sticks always pick up other colors when you're working with them, or just from coming into contact with loose pastel in supply boxes. A good way to clean sticks is by placing them in cornmeal, as I have in this hinged box, which I seal and shake for a few minutes.

Caring for Finished Works

Pastel is a very fragile medium. The best protection for a finished painting is a double window mat, behind glass, in a sturdy frame. Most important is that the glass never touch the pastel, which could adhere to or smudge the glass.

MATTING

The first step in protecting a pastel painting is to secure it to a solid backing of mat board or Fome-Cor (lightweight laminated panel), with a double window mat placed on top. The double mat keeps the pastel paper surface separated from the glass, so even though natural changes in humidity may swell or buckle the paper, it won't touch the glass. Some artists and framers include a third mat with a window opening cut larger than the top window mat, placed between the pastel image surface and outer mats to create a shadow-box effect. This inner mat acts as a trough or gutter to collect fallen or dislodged pastel particles, and helps keep the outer mats clean. The only drawback is a slight shadow cast by the mat edge onto the painting surface.

Avoid using garish mat colors; understate rather than overstate. Of course, the mats should complement the overall colors of your painting.

Attractive and economical basic mat board is fine for beginner art. As you progress from serious beginner to a pastelist who plans to exhibit work, more expensive rag mats or archival materials will be better choices for framing your paintings.

GLASS

Various types of glass may be used to cover a matted pastel painting, but some should definitely be avoided. Nonglare glass is one to avoid; it's expensive, brittle, produces a fuzzy image, and magnetizes pastel particles to the glass surface. Don't use it. There is also a museum-type glass that reduces glare, but it's very expensive. Choose what many professional pastelists use: picture glass or ordinary window glass.

FRAMING

Adding a frame is the final protection for your pastel painting. Metal frames are economical and easy to assemble, but have the drawback of scratching easily. Wooden frames are my best recommendation, but they are more expensive than metal and often require additional tools, or professional help from a framer, to put together. I suggest you check catalogues, local shops, and art-supply discounters, watching for sales to build your own inventory of stock-size wooden frames at reduced prices.

Your pastel painting, protected by mats, glass, and frame, is ready to be hung, and should be safe from any possible harm. But do remember that paintings should not be hung in direct sunlight.

STORAGE

Framed pastels should be stored upright or face upward in a cabinet with pieces of cardboard or bubblewrap separating each framed painting. Unframed and unmatted pastels should be stored in the following careful manner.

Buy sheets of acid-free glassine paper (available in art-supply, paper, and photography stores and catalogues). Interleave the glassine with your pastel paintings as you lay them one on top of the other in a flat pile. Glassine paper minimizes the amount of pastel transference. Then use bulldog clips to hold the edges and stabilize each surface from moving and rubbing against the next. Make sure you don't store anything else on top of this paper unit.

Sometimes, old pastel drawings are not worth saving and can be used as a recycled surface for the next drawing by either gently rubbing the surface with soft tissues, paper towels, or rags to erase most of the pastel, or by using a stiff brush to dislodge the pastel from its surface. The restored ground will accept pastel; though not as good as new paper, it's certainly acceptable, especially for exercise studies and experiemental work.

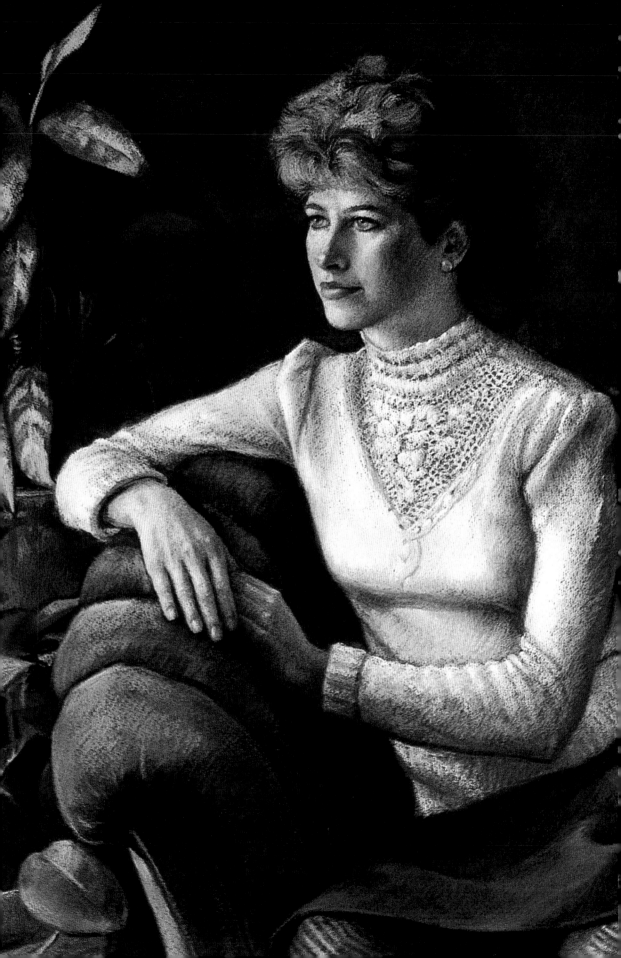

Fundamentals

Your materials are neatly assembled. A crisp sheet of paper is mounted on a board, resting on your easel. Nearby, a big bouquet of fresh flowers is waiting for you to translate it into a wonderful, colorful pastel painting.

Before you reach into that enticing and vibrant rainbow of pastels spread out next to you, be sure to read this chapter, which reviews the most important fundamentals that will guide every pastel painting you'll ever create.

Color is the first basic to be explored. Knowing the properties of color—hue, intensity, and temperature—helps us to understand why certain colors work well together and others don't. I particularly emphasize the fourth property of color, which I consider to be most important: value—the degree of lightness or darkness of a hue.

Whether you're working indoors or out, the effects of light and shadow are critical to the look of a still life, portrait, or landscape painting. I'll discuss different kinds of light sources and how they affect surfaces; how to express highlights, halftones, and reflected light; and how shading and cast shadows add dimension and dramatic effects to a painting.

Next we'll deal with creating form and volume—the shape and solidity of an object—which begins with a look at simple geometric concepts, such as the circle, the cylinder, and the square, and how your artist's hand can evolve them into the face, the tree, the house you wish to portray in your pastel painting.

How to paint perspective—bringing an illusion of depth and space to an image executed on a flat piece of paper—is one of the most challenging feats confronting the artist. Guidance on handling this important fundamental will be found in the final pages of this chapter.

DAWN (DETAIL)
Pastel on paper, 26 × 40"
(60.9 × 101.6 cm).
Collection of the artist.

A dark background provides bold contrast with cool light focused on the face and bodice in this three-quarter portrait.

Color

Color has four characteristics: hue (what we commonly think of as the color's name); its value (lightness or darkness); its intensity (brightness, or saturation); and temperature (warm or cool).

HUE

The colors of the spectrum as found in nature and classified on the traditional color wheel are:

- **Primary colors.** Red, yellow, and blue are termed primaries, the colors from which all others are derived. They cannot be created by mixing any other colors together.
- **Secondary colors.** Colors produced by mixing equal properties of two primary colors are called secondaries: orange (red and yellow mixed together); green (yellow and blue mixed); and violet (blue and red mixed).
- **Intermediate colors.** Mixing a primary and an adjacent secondary produces intermediates: yellow-green, blue-green, blue-violet, red-violet, red-orange, yellow-orange.
- **Tertiary colors.** Mixing secondaries together (orange, green, violet) in any proportion produces tertiaries.
- **Complementary colors.** Those directly opposite each other on the color wheel, known as complements, are assumed to be as different as two colors can be. The six pairs of complements are yellow and violet; yellow-green and red-violet; green and red; blue-green and red-orange; blue and orange; blue-violet and yellow-orange. Analogous colors are those that share the same primary (for example, red-violet and red-orange).

VALUE

The value of the color refers to its degree of lightness or darkness. A color that's almost white (such as pink) is called a light value, while a color that's almost black (such as maroon) is called a dark value. However, a dark color can be lightened by adding a lighter color or white to it; a lighter color can be darkened by adding a darker color or black to it. Thus, adding white (tinting) or black (toning) changes the value of the color. This is exactly how pastel manufacturers create the values of each chalk stick. Value will be discussed in greater detail later in this chapter.

INTENSITY

The degree of saturation of a color is known as its intensity—how bright the color is. A pure red is saturated with the hue while a light red is less intense because the red has been tinted with white. Adding another color or value to the original color reduces its strength, or intensity.

TEMPERATURE

Color also has temperature: warm or cool. Related to sunlight, warm colors are reds, oranges, and yellows; cool colors, associated with shadows, are blues, greens, and violets. But color temperature is also relative. An ocher yellow may appear cool when placed next to a hotter orange. Relative amounts of colors mixed together also affect temperature; violet with a lot of blue in it is seen as cool; on the other hand, it becomes warm if it's a red-violet. Within the hues themselves, colors can change from warm to cool. Warm cadmium red light leans toward orange; cadmium red medium is a neutral red; cadmium red deep becomes cool as it leans toward blue.

Another important point about color temperature is that cool hues seem to recede, while warm colors seem to advance, characteristics to be considered when composing your paintings.

Referring to the information above, how would you classify each of these patches of pastel color in terms of their hue, value, intensity, and temperature?

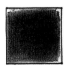

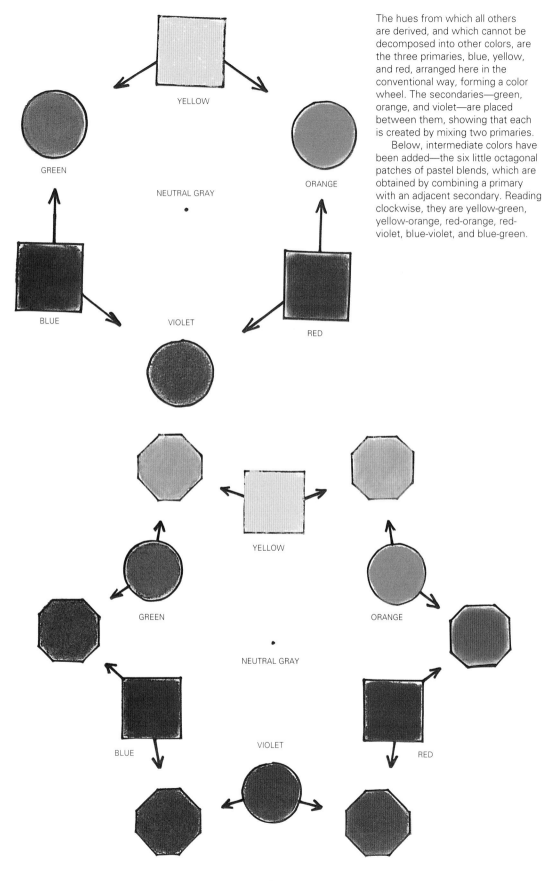

YELLOW

GREEN

NEUTRAL GRAY

ORANGE

BLUE

VIOLET

RED

The hues from which all others are derived, and which cannot be decomposed into other colors, are the three primaries, blue, yellow, and red, arranged here in the conventional way, forming a color wheel. The secondaries—green, orange, and violet—are placed between them, showing that each is created by mixing two primaries.

Below, intermediate colors have been added—the six little octagonal patches of pastel blends, which are obtained by combining a primary with an adjacent secondary. Reading clockwise, they are yellow-green, yellow-orange, red-orange, red-violet, blue-violet, and blue-green.

YELLOW

GREEN

ORANGE

NEUTRAL GRAY

BLUE

VIOLET

RED

Tertiary colors (the round patches) result from combining two secondaries. The subtle hues produced are often found in nature, making them very useful for painting pastel landscapes: the bark brown that results from a violet and orange blend; the leaf green that comes from blending secondary green with orange; and the stone gray made by mixing green and violet.

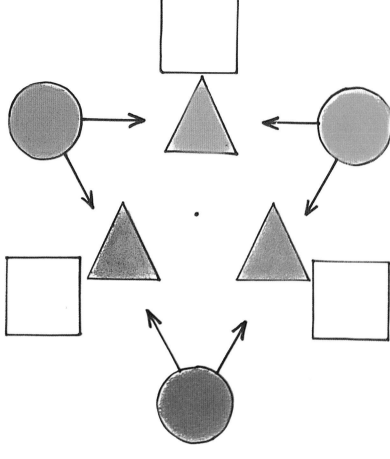

Instead of mixing black and white to produce gray, look at the warmer and more lively neutrals to be had by blending primaries with secondaries.

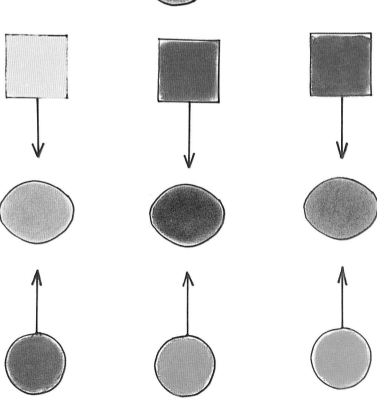

COLOR MIXTURES: PHYSICAL VERSUS OPTICAL

Pastel colors are either physically mixed by blending, or optically mixed by a wonderful trick that our eyes play on us.

A typical physical mixture of pastel colors would be blending yellow into blue to create green. An optical mixture would be placing yellow and blue side by side (hatched or cross-hatched) to create an illusion of green—seen as that hue because the eye has combined two colors to create a third. It's the same process as viewing a shirt of fine red-and-white stripes at a distance. The two colors will blend together optically and read as pink.

An advantage of planning optical, rather than physical, blends in certain paintings is that optical blends can be manipulated to much brighter hues than physical blends. Rubbing colors reduces the refractive aspect of pastel and dulls the mixture slightly. The more colors one combines, the more likelihood of reducing color clarity. However, sometimes the artist may want colors physically mixed and dulled for technical, spatial, or contrast reasons. By practicing both mixing methods, you'll increase your knowledge of color behavior and bring variety to your pastel paintings.

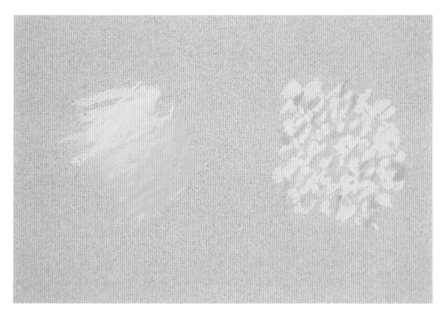

At left, when yellow pastel is blended with blue, the physical mixture produces an actual green. At right, an illusion of green is achieved by closely intermingling yellow and blue pastel strokes that the eye then blends optically, very like the Pointillist technique made most famous by the French painter Georges Seurat.

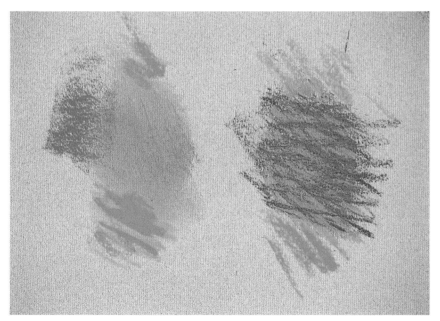

Orange and blue, directly opposite each other on the color wheel, are called complements. At left, they are rubbed together physically into a warm brown. Changing proportions of the two colors will produce many subtle variations. At right, cross-hatching blends the colors optically.

EFFECTS OF MIXING ON HUE, VALUE, AND INTENSITY

How colors behave when you mix them will become second nature to you as you continue to work with pastels. Here are some rules, randomly presented, that will soon be very familiar to you.

- When colors of equal intensity, value, and proximity on the color wheel are mixed together (yellow and orange, for example), the new color (yellow-orange) will retain almost the same intensity as the original colors; only the value will change.
- When colors are mixed together that are close to being complements (not exactly opposite each other on the color wheel, such as yellow and red-violet), signs of an intensity reduction will be seen. The greatest intensity and value reduction comes from mixing true complements.

- Placed side by side in a painting, complements intensify each other because of the vivid contrast between them. For example, blue and orange strengthen each other visually.
- But when complements are mixed together, they neutralize each other's intensity; in combination, red and green produce a reddish or greenish brown.
- Even when a minuscule amount of a color is mixed with its complement, a slight color change results. Any amount of added color will modify the mixture in both value and intensity, although the unpracticed eye may not always perceive these subtle alterations.
- If a dark-value hue is combined with its near complement (let's say blue mixed with red-orange, a lighter value), the resultant mixture is not only changed in hue, but also in value.

The combination of yellow and green is one you'll use a lot in landscape paintings. Let color work for you by continually experimenting with gradations within a blend, as shown here.

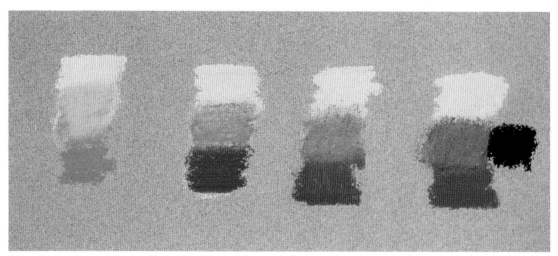

A very instructive exercise is taking one color—in this case, yellow—and combining it with a succession of other hues. When used in a painting, analogous blends—those that share the same primary—bring unity and cohesion to a composition.

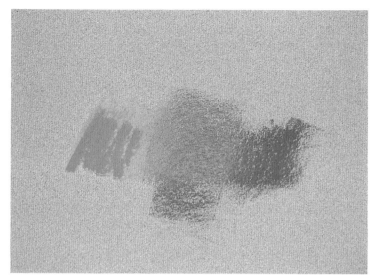

Though this combination was shown earlier, blue and orange mixtures are so useful for landscape and other work calling for neutrals, that I include it again—this blend being a bit lighter in value than the earlier one. Experiment with blends, noting on your test sheets the names and numbers of the pastel sticks you used, to build your own color-reference library.

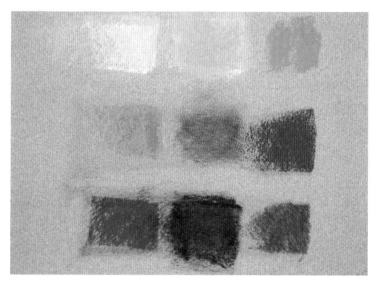

Each center patch is a blend of the pastel on the right put down over the one on the left. A small amount of violet (which was lightened first with white) over yellow produces a useful flesh tone. Note how the very saturated blue over orange gives a greenish neutral versus the browner one resulting from the orange-and-blue blend at the top of this page. A rich brown results from the green-and-red blend.

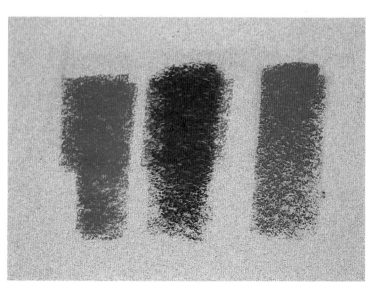

Value often changes along with hue when colors are mixed, as in this blue-over-red blend that becomes deeper in value than the red is originally. Color temperature alters as well. Cool blue over warm red in the proportions shown here makes a warm neutral brownish shade.

A light value mixed with a darker value color will lower the value of the *light* to a middle mixture between the two original values.

BLACK, WHITE, NEUTRAL GRAY

Used by themselves and as blending tools, black, white, and grays are important parts of the pastelist's palette. Here are some basic facts about them.

- Grays are mixed in two ways. As stated above, two complements blended together will neutralize the color of each and move the mixture toward a maximum reduction of hue identity—neutral gray. With patience, practice, and dexterity, the pastelist can achieve various subtle degrees of neutral gray by adjusting the ratio of the two complements.

- The second, and perhaps most familiar, way to mix gray is by blending black and white, but the gray that results is not the same as that derived from complements, since black and white are achromatic (without color).

- Adding black or dark gray to a mixture will further dull the color. Why? Because black absorbs the greatest amount of light present in a color combination. Black, as a mixing value, is therefore the maximum dulling agent.

- Adding white and/or black to a pure pigment color reduces its intensity, producing a lighter tone or a darker shade of a given hue. The manufacturers of pastels add varying amounts of white and black to each pastel color to extend its range up and down the value scale.

Though the color on the left may appear greenish to you, I classify it as a neutral gray blend. To most people, *gray* means a blend of black and white, as shown on the right, but in my artist's lexicon, *neutral gray* applies more broadly to grayed, nonspecific hues.

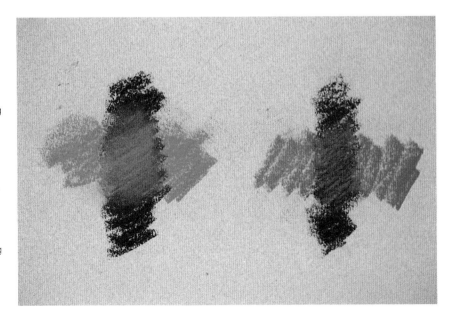

Adding black or gray to these primary colors also produces neutrals. To see the neutral centers more clearly here, cover the extended black, blue, and red areas by tearing a peephole in a piece of white paper, then placing the opening over the blended center, blocking out the surrounding colors. The color surrounding a center color affects the visual center color either by emphasizing the intensity or changing the hue identity.

TINTING STRENGTH

Another element of color that must be taken into account when you are mixing pastels is the particular tinting strength of each color. The more experienced you become at blending, the more you'll discover the relative strength of colors when they act as tints. You must particularly watch out for those pigments that are much more intense than others, and therefore require a smaller percentage in the mixture, or they will radically dominate the combination color.

For instance, alizarin crimson is quite powerful, so a very small amount of it will make a big impact when mixed with any other color. Conversely, green earth (terre verte) has a very low tinting strength, so any color mixed with it will be dominant.

OPACITY AND TRANSPARENCY

Another vital color discovery for the artist is how inherently opaque or transparent colors are, and how to adjust those qualities to suit the needs of the painting at hand. The techniques of certain mediums are based on their transparency, notably the see-through nature of watercolor, which relies on using the white of the paper as an optical mixing white. On the other hand, opaque mediums such as gouache and oil require a solvent to dilute and give transparency to the pigment.

Adding black, on the left, and white, on the right, reduces the intensity of this orange hue. Black is the maximum dulling agent; adding it *shades* a color. When white is added, the hue is said to be *tinted*.

Degrees of complement are shown here, as direct opposites on the color wheel are mixed. I started with the red-orange blend on the left, a primary blue on the right, and gradually worked them together in the center.

Pastel, which is also an opaque medium, can be manipulated to create transparent effects by thinning the color with water or turpentine. The thinner the color mixture is, the more light will pass through on its way to the next opaque paint layer or ground.

Pastels can also be made to appear transparent by applying light strokes over established colors. The overlapping color may be just touching the uppermost fibers of the paper while leaving spaces or openings for the underneath color to show through. This is an optical mixture rather than a physical one, and a grteat many very beautiful subtleties can be created this way.

The opacity of pastels renders them quite correctable, making this an especially friendly medium for the beginner. How to hide or obliterate previously applied colors is a technique that will be elaborated on elsewhere in these pages.

COLOR AND LIGHT

Artists have been intrigued by the effects of light on color for centuries, perhaps no group more so than the Impressionists, who continually experimented with depicting changing light both in oil and pastel paintings. Here are some of the basics that guided them.

- A bright light source tints color, both lightening and decreasing its intensity. Low light neutralizes or grays down color and lowers its value.
- Local color is the intrinsic color of an object, which changes as light hits it. If you were portraying a red beach umbrella bathed in direct sunlight, the color should be far more intense than the blend you'd use to portray the red beach ball lying in the shade underneath the umbrella.
- Illuminating light has another property: temperature, be it warm or cool. North light,

DRIVING HARD
Pastel on paper, 24 × 18"
(60.9 × 45.7 cm).
Private collection.

Blue, green, and white had to be predominant in this painting of sky and water. But a *plein air* painting that's exclusively one color temperature with similar values throughout risks looking unnatural and monotonous. When the colors are cool blues and greens, which tend to recede, the subject matter may even seem remote. My first solution was to bring color variety through good value contrast by lowering the value of the blue-greens of the water. Then I blended some complementary reds and oranges into the blues and greens of the water to bring some warmth into their deep shadows, providing contrast, which also helped to advance the foreground toward the viewer. Some of those warmer touches are also in the silhouetted figures on the boat and on the rail trim, and the tiny patch of red stripes of a flag peeking through behind those figures lends a note of unexpected color contrast. Compositionally, the billowing sail that commands the upper left quadrant is counterbalanced by the boat and deep cast shadows that dominate the lower right foreground.

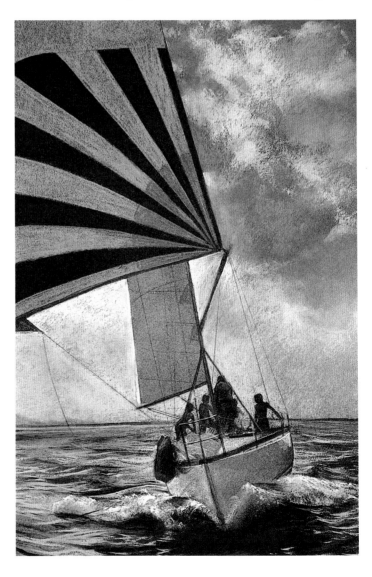

considered cool, is bluish and is often given that cast in paintings. Incandescent light is usually warm and is often depicted with a yellowish glow falling on objects.

- The angle of light as it reflects on surfaces also affects the way we both view and paint an object's color. Surfaces angled away from the viewer appear lower in light and intensity.
- Both light and color are also reflected off adjoining surfaces onto objects, but with a reduction; all are lower in value and intensity than lights and colors on the side of the object receiving the full intensity of the original light source.
- The color value of the reflecting object governs the amount of light reflected onward. The lower the color value of the reflecting surface, the more light will be absorbed and less light/color will be reflected back to the object.

- White absorbs the least amount of light intensity and reflects the most light, while black absorbs the most light and reflects the least. The texture of a reflecting surface also plays an important role. Rougher textures will bounce light in many directions, and therefore less light/color will be reflected to the object. On the contrary, a smoother surface will refract less, and reflect more.

COLOR CONTRAST

Color contrast is the degree of change in hue, value, intensity, and temperature in comparison with another color area, and has useful spatial connotations. The smaller the contrast, the equally smaller change in space. Conversely, increasing contrasts increases the amount of space between color objects or areas in a pastel painting.

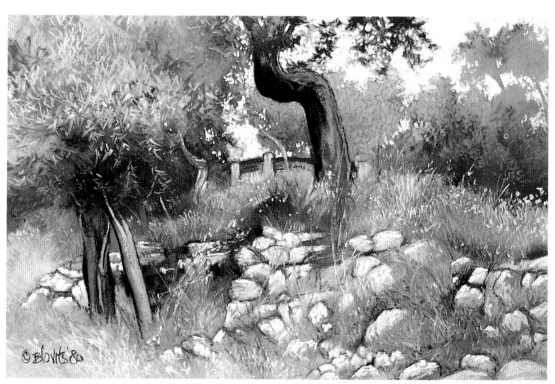

OLIVE TREES
Pastel on paper, 13 × 19"
(33 × 48.3 cm).
Private collection.

An unusual tree trunk caught my eye and became the centerpiece of this pastel painting. The hint of a structure in the background—it might be read as a low bridge or a fence—is deliberately vague to suggest a sense of distance and perspective. Its neutral grays relate to those in the foreground stones, a device that helps unify a composition. Cool blue-greens dominate the upper half, warm yellow-reds, the lower half, but touches of each of these opposing temperature groups are brought into the other area, serving to solidify the painting even more.

Awareness of color contrasts, as they relate to the illusion of space, is a tremendous help to the serious beginner in pastel art. Another spatial contrast, for instance, is that the strongest and/or brightest color will appear to come forward in a picture plane in the presence of neutralized or dulled colors. The amount of difference is coordinated with the various spatial separations desired. Variety and intensity epitomize the foreground colors, while the light, closely associated opposite colors contrast against those in the foreground, and recede in space.

Occasionally, the color properties of a complement or black are useful to help emphasize the opposite characteristics of an adjacent color. For example, a light, bright red will look even lighter and brighter in a dull, dark, or black environment compared with the same original red color in a middle-value or lighter environment. Experiment mixing these colors to discover all the possibilities.

The great artists of the Renaissance teach us a lot about how color contrast can create an aura of space on a canvas: Place maximum variations in the foreground—such as value and color changes—gradually reducing them to a minimum in the background to create an effective illusion of deep space.

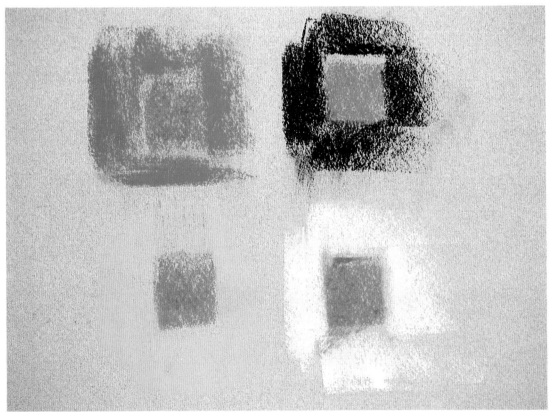

Color is affected by its environment. Observe how different the same red appears in the above four squares, even though the same pastel stick was used for each. Surrounding red in the square at upper left with a blue-red of equal value reduces the square's brightness and optically changes the hue's identity. See how much more intense that red is when it's enclosed in white? Keep this principle in mind as one of the ways to bring attention to an object or divert the viewer's eye away from it.

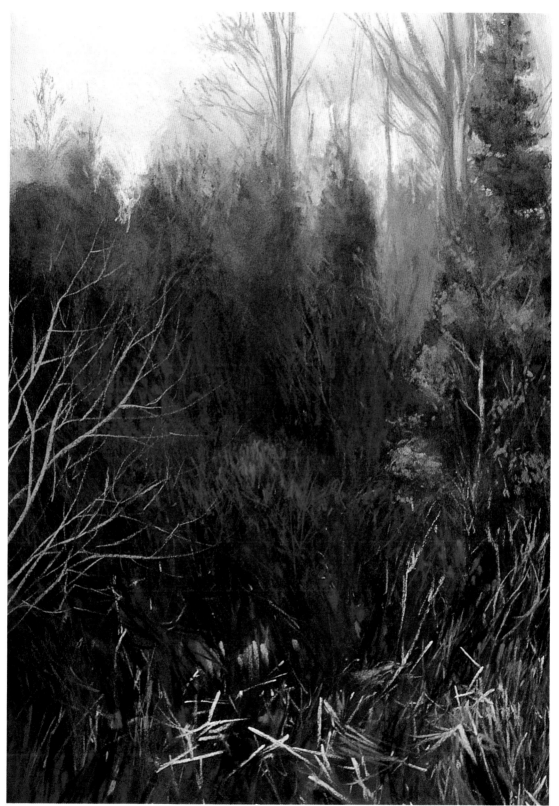

WINTER HARVEST
Pastel on paper, 22 × 18"
(55.8 × 45.7 cm).
Collection of John Ladd.

Both physical and optical blends of color were employed to produce the gradations of green in the tallest tree to the right. Strokes of red enliven an area of dense, dark brush. The foreground strokes of white and other light tones were the last details I added after all the dark areas were fully developed.

Value

Value is an artist's term for degree of light or dark on a scale of grays running from white to black. Chromatic colors can be similarly evaluated; the darker ones are said to be lower in value.

The value scale is divided into nine equal steps (the rate of change being the same in each step) from white to black. A value scale without color is called achromatic; a value scale in one color is called monochromatic. This value characteristic, when using color, is only one of the factors present. All are important, as you will see.

Values matter to pastelists in many ways. A sequence or progression of values, from light to dark, for example, helps to produce the illusion of roundness or volume. A difference in the unit's value, whether small or large, also helps to create an illusion of space or depth between objects. A similarity of value helps to group objects or colors together in a plane or near-plane. Value can also play a part in creating the illusion of light within the picture plane.

Comparing the values of colors to a value scale purchased from an art store will increase your observation skills. Squinting diminishes the visual effect of color, making it easier to read value. While squinting, check both your model and drawing, back and forth. If you notice an incorrect value, change it until you have a perfect value match while squinting. This is a solid approach.

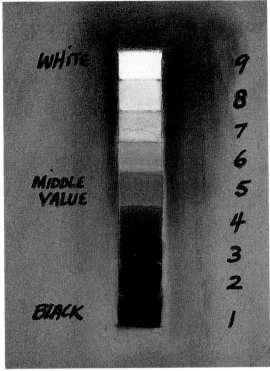

This achromatic value scale shows equal gradations from black to white. If you build a chromatic value scale for each and every pastel stick corresponding to the color-wheel hues shown earlier, even if you work on only a few a week, you'll soon have a valuable basic color-reference library.

Value changes have given volume to this orange, which started its life on my paper as a circle filled in with flat color, then I added lighter values and shaded to darker ones to give it roundness and three-dimensionality.

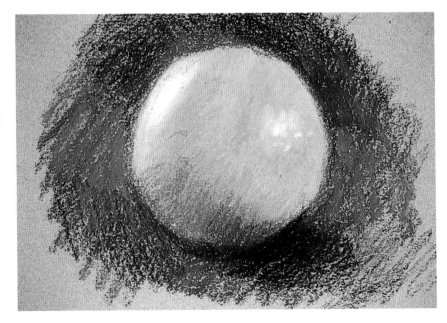

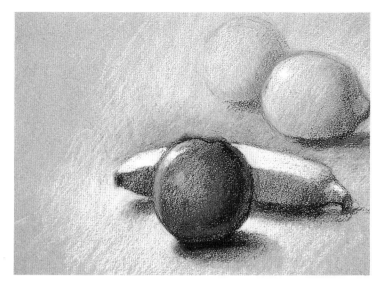

One reason there's a sense of depth to this little still-life study is that the value changes are so strong from the lower-value, very dark orange in the foreground to the high-value, very light lemons in the background. Without that great value contrast, all four pieces of fruit would seem to be much closer together.

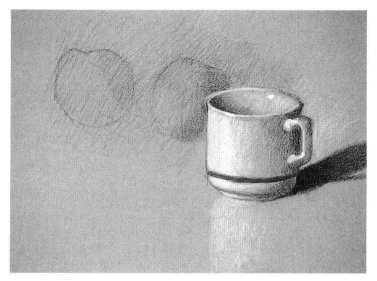

A similarity of value characterizes this grouping. Referring to the scale on the page opposite, the higher values will be found mostly in this cup and apples, but there's still enough contrast on the cup, particularly, to produce convincing contours and value changes, so that we know we're looking at a three-dimensional object.

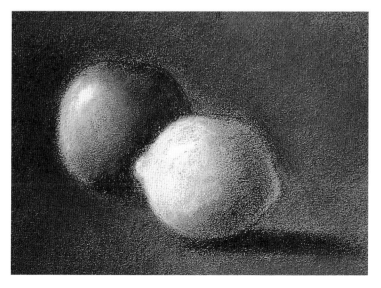

An illusion of light within the picture plane is created here through changing values—from the lower values of the background, to the highest values found in the bright little points of light on both pieces of fruit. The contrast between the higher-value foreground fruit and the lower-value piece behind it creates a sense of space between them.

Light and Shadow

Although some aspects of light have already been discussed, the subject is so central to the creation of fine pastel paintings that I'd like to expand on it further, starting from the most basic points about light.

Obviously, light enables the eye to see color, form, texture, depth, description, and detail—everything. Two main types of light are used by the artist: natural (sunlight) and artificial light (incandescent and fluorescent lamps, neon lights, spotlights, candlelight).

The intensity of sunlight varies, depending on weather conditions and time of day. The challenge for the *plein air* painter is coping with the sun's intensity changes, its continual movement in the sky, plus shifting cloud patterns. The intensity of artificial light is determined by the wattage of the bulb; the higher it is, the stronger the light/shadow effects are on objects.

Whether natural or artificial, the light source illuminating a given object creates a light side of the object, a dark or shadow side, and a cast shadow. These have further divisions within them, with a vocabulary all their own to identify the several kinds of light that must be interpreted in order to express dimension and depth in your paintings. Some of these concepts will be expanded on later in this chapter.

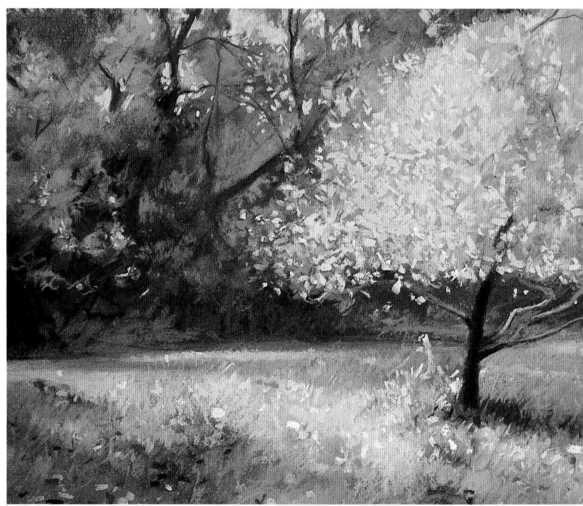

AFTERNOON LIGHT
Pastel on paper, 18 × 24"
(45.7 × 60.9 cm).
Collection of Phil Dennen.

Bathed in sunlight streaming down from the left, this tree became a brilliant focal point for a landscape painting. The streak of sunlight cutting across the lawn in front of the tree reinforced the definite direction from which the light was emanating. The darker side of the tree, its long cast shadow, and background areas in shade all provided good contrasts.

- **Highlight.** The very lightest color value on an object is its highlight, painted with the color value closest to white. It is the point of greatest illumination and reflectance.
- **Halftones.** Any lower color values between the highlight and the darkest color value displayed on the object are halftones. Whether light or dark halftones, they should still contain enough illumination to discern color, and some detail.
- **Core.** The darkest value on an object, because it faces away from the light source, is called the core. Color and value change are hardest to perceive here.
- **Reflected light.** Next to the core and farthest away from the light source is reflected light, also called ambient light, which is light that has bounced off another object or surface, and is much weaker in intensity than the original light.

- **Cast shadow.** The shape of an object silhouetted on an adjacent surface away from the light source is its cast shadow.
- **Shade.** Shade is defined as that area of an object that doesn't receive any direct light.
- **Concentrated light.** The strongest illumination, closest to the light source, concentrated light is severe, originating from a brilliant spotlight or floodlight, and is often used for dramatic touches on portraits (particularly male portraits). Intensely bright sunlight hitting an outdoor subject is another example of concentrated light.
- **Diffused light.** Soft light such as that of an overcast day allows enough visibility to see all colors, values, and details, but without the bleaching or darkening characteristics found in direct light or shade.

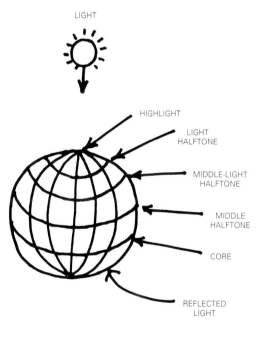

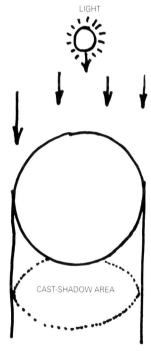

Use this diagram as a guide for perfecting your form-building skills. Replicate the color-value pattern formed when light comes down directly from above on an orb, by setting up a mini still life of three apples: green, yellow, and red. Direct an overhead light on them, then, referring to the values in the diagram as you study your still life, apply and blend your pastel colors.

Direct overhead light beaming on an orb creates an elliptical cast shadow. An additional reduction of color and value occurs in this area, especially nearest the object casting the shadow. Apply this principle in painting the green, red, and yellow apples described in the caption to the left. Don't be surprised if this practice project produces a charming little still life for your wall.

COLOR IN SHADOW

An object receiving light blocks that light from reaching the other side, and also produces a cast shadow. Therefore, the shaded side and cast shadow are found on the object's side opposite the light source. You should check to see that all shadows in a composition are consistent with the direction of the main light source. Also be sure to reduce the clarity and intensity of shaded elements accordingly. The deeper the shade, the harder it should be to see and recognize color and structure in that area of your painting.

The artist learns to recognize the properties of shadow colors by mixing the pure hue with either its complement, degrees of gray or black, or both. The closer the color value is to black, the harder it is to see and recognize.

Your shadow color components should affect and combine with the area's color elements covered by the shadow. If, for instance, a shade color is designated as a blue transparency, then a cast shadow combined with a red surface would result in a violet (blue plus red) cast shadow color.

The edges of the cast shadow conform to the underneath's surface curve or plane. For instance, a cast shadow falling over an arm would most likely have a curved outline rather than a straight edge. If the same cast shadow fell over a flat table surface, the shadow edge would be straight. Of course, the edge of the shadow would only be apparent on the lighted side (where the light on the form and presence of cast shadow are evident), and would not be evident inside the shaded area (little or no light available to show form; everything's in shade).

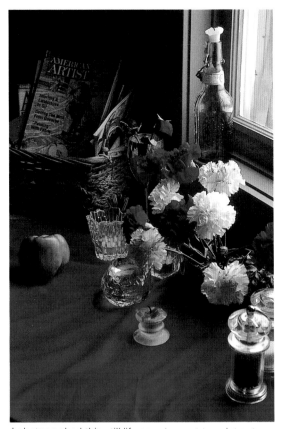

I photographed this still-life arrangement to point out how light patterns fall on the differing textures of flowers, green pepper, and glass. Also note how the position of these many objects relative to the light source alters the degree of shadow reduction in clarity and color. While the single light source from the window puts shade mainly on the left side of individual objects, the color values that come through in the shadows on the carnations are clearer than those on the green pepper, because the flowers are nearer the light source.

Strong light coming in from the right throws the left side of this apple into deep shade. Though color becomes harder to discern when shaded this much, both red and yellow would be subtly present in the low-value pastel colors that would be used to depict the reflected light on the left side of the apple. Note the transparency of the cast shadow.

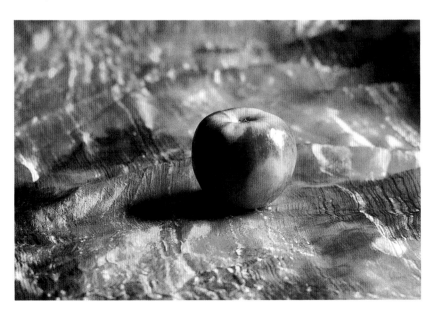

CONCENTRATED LIGHT

When you wish to lend a brilliant or dramatic effect to your subject, concentrated light brings intensity, definite shadow edges, and contrasting dark-value shaded areas and cast shadows.

As noted earlier, concentrated light usually originates from a close, strong light source such as a spotlight, which floods the receiving side of an object with bright light, eliminating all shadows and substantially reducing the visual evidence of value change on that side. The light side is very light compared with the dark of the shadow side. There's also a definite shadow "edge" separating light and dark areas, and a cast shadow that is a well-defined shape and often designated as a flat value.

Since the light source is so close, light rays expand as they travel to the object. This divergence becomes very important in describing the configuration and orientation of the strong cast shadow. Concentrated light also produces the maximum tinting of color on the illuminated side. Values observed there are very subtle; the same happens in the shadow area, including the reflective light.

If using concentrated light for a portrait, take care not to place the spotlight too close to the subject, as it will be uncomfortable and blinding for the model.

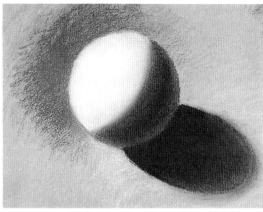

In concentrated light, the value change from the light area into shadow is very abrupt. On the light side, there is a highlight on the object, followed by a gradual sequence of very light halftones. After a fast transition in value at the shadow edge, the shaded side has a subtle sequence of dark halftones to a slightly darker core.

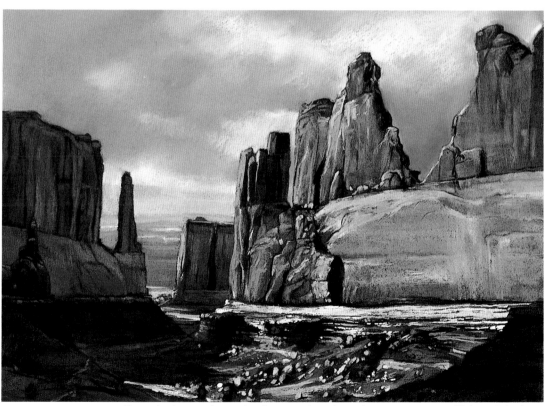

UTAHIAN I
Pastel on paper, 18 × 24"
(45.7 × 60.9 cm).
Collection of the artist.

Dynamic shapes, plus cool and warm colors shown in strong contrasts of light and shadow, made this vista an irresistible subject for a pastel painting. Observe the many color blends I used not only in the cliffs, but in the sky as well. Resist the inclination of many newcomers to this medium to use blues and whites exclusively when painting skies.

DIFFUSED LIGHT

The gentle aura of an overcast day produces soft, diffused light. It's often ideal for depicting a tranquil scene or a female figure in a composition.

When you are painting a subject in diffused light, the elements of highlight, halftones, core, and reflected light continue to be used for creating volume, but the sequence of value change is much more gradual. Having a softer and less intense glow than direct sunlight, diffused light shows contrast differences in color value that are greatly reduced, bringing light and dark values much closer together. In fact, only about a third of the value scale is represented in diffused light. Referring to the Color Value Scale shown earlier, the highlight may be value six; halftones range from value five to three and a half; the core at three; and reflected light at three and a half or four.

The value changes in forms are very gradual, as opposed to the sharp contrasts observed under concentrated light. Transitions from one area to another are more subtle, less abrupt. With diffused light, there is a maximum of reflected light and a minimum of dark shadows. The cast shadow is more of a suggestion than a definite shape. It goes through a disintegrating process, gradually fading and eventually disappearing into the value of the environment.

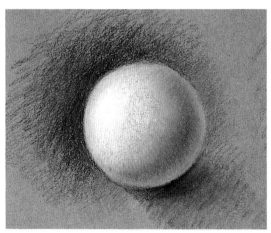

A sphere in diffused light has a very subtle sequence of value changes, and only about a third of the value scale of nine degrees of light is represented.

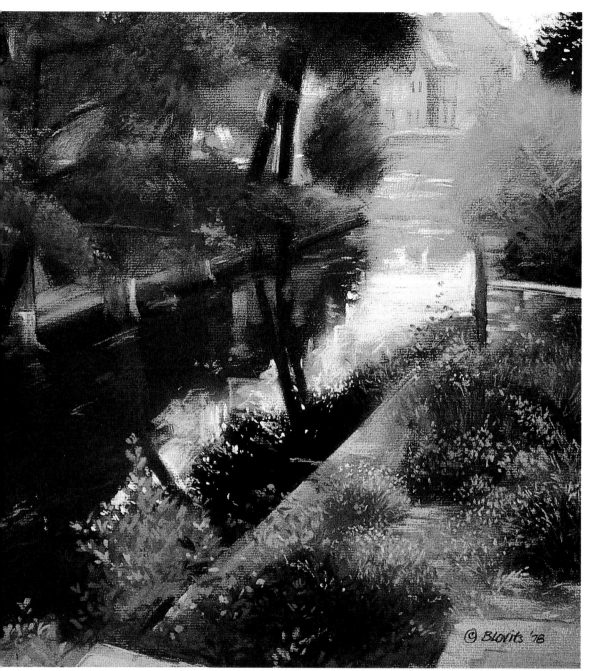

PEACEFUL CHARTRES
Pastel on paper, 16 × 22"
(40.6 × 55.8 cm).
Private collection.

With the sun concealed under cloud cover, soft light added still another measure of serenity to this invitingly placid setting. None of the bright bleaching effects of direct sunlight are present, yet an overcast sky still allowed enough good visibility for me to see and record colors, values, and details in my painting. Cool blue-greens are the dominant color blends, but warm touches of yellow, raw sienna, and burnt umber broaden the palette here and there. A tranquil canal such as this always offers the *plein air* painter a wonderful foil for abstracting shapes as they reflect on the water. Parts of structures hidden behind foliage lend some mystery to a setting. When a building in your landscape painting commands more attention than you had intended, do your own "planting" by taking the liberty of fabricating trees or bushes as foreground interest to break the severity of architectural lines.

LIGHT FALL-OFF

Light reduces in intensity, or "falls off," as its rays travel through space from the source to the subject matter—such as farther into the interior of a room. But the contrary is true of shadow. Its value remains constant, regardless of position. The contrast between light and shadow is blatantly evident at a position closer to the light source and reduced by increments as distance from the light source increases. The intensity of the light is additionally absorbed and reduced by reflecting objects and surfaces on its way to its destination.

The "fall-off" of light is best exemplified by candlelight. The closer the object to the candlelight, the easier it is to read its color, texture, and form. However, due to the very low intensity of light, these readable elements are diminished rapidly as the distance from the light source increases.

COLOR TEMPERATURE

Let's detour briefly into color science, which explains why cool and warm colors are so designated.

The color of light on nature's spectrum is described in terms of color temperature, which is measured in Kelvin degrees, designated K. The lower the light on the Kelvin scale, the warmer it is. Candlelight and incandescent light bulbs are warm by comparison to daylight. Northern daylight is decidedly cool.

The setting sun is rated at 1500° K and is reddish-orange; at 1900° K, the same sun looks orange. A forty-watt light bulb is rated at 2650° K, 200 watts at 3000° K—still on the warm or yellow side of the spectrum. Daylight on a sunny day is rated at

5500° K and is rather neutral in color, a white light. Light from the north sky is rated around 15,000° K, and is decidedly blue in color.

The color temperature of light falling upon an object affects the way we see that object's color. To depict a certain type of light, or time of day, the color temperature of the light must be accurate. White objects, early in the morning or at sunset, will appear reddish because of the illuminating light's lower color temperature. This creates a dilemma for the artist trying to paint a white lily. Because of our visual memory of that flower, we still think of it as "white," even though it's observably reddish under early morning light or sunset. This phenomenon is called *color constancy.* Although the mental process of color constancy is automatic, the artist can choose to be more observant and override this tendency. To depict a white lily in early morning light accurately, the artist allows for the influence of early morning color temperature and tints white flowers with red or orange.

Another of nature's rules to keep in mind: The temperature of light usually produces the opposite temperature in the shadow. A warm light will make the shadow look cool, and vice versa.

Fluorescent light is typically more on the yellow-green or blue-green side of the spectrum. Various manufacturers make special color-corrected fluorescents for artistic specifications.

CONSISTENCY OF LIGHT SOURCE

For the artist, a consistent light source that doesn't change intensity or temperature is highly prized.

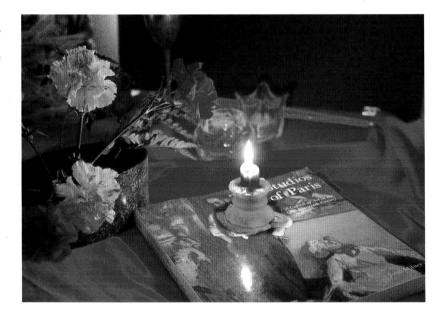

This photograph of a still-life setup shows how low-intensity light on objects nearest the flame quickly reduces as fall-off light moves farther from its source. This is a good example of light fall-off.

Artists often use an identical light source to illuminate all three areas involved: subject matter, painting surface, and palette. Consistent light falling on all three helps to create a unity of color vision, evaluation, and application.

When you are painting outdoors, time of day is a special consideration. Artistically, early morning and late afternoon light are most desirable because of their color effects, the definite shadows and cast shadows produced at those times, and the low angle of light defining surface texture and details.

Because of the east-to-west movement of the sun from sunrise to sundown, most artists prefer to work with north light as their natural source in the studio. On the cooler side of the spectrum, north light is the most consistent, with little noticeable intensity or temperature change throughout the day. Artificial lights purchased in coordinating Kelvin-rated daylight temperatures provide optical consistency for observing color and applying it, day or night.

Different effects are produced by altering the distance between light source and subject matter, the number of lights, and their intensity. Too many lights coming from different angles will visually flatten objects by eliminating form-building shadows, thereby confusing both the artist and the viewer. One dominant light source is recommended. An additional subordinate light can be used to produce reflected light to emphasize form, by placing a lower-wattage bulb nearby, or a second bulb of the same wattage, as the dominant light, farther away from the subject matter. Reflected light should never be near the same intensity as highlights. In fact, when you are squinting, the reflected light value should relate closely to the core—the darkest value located on the form.

Using too many or equal-intensity bulbs will create problems. For example, two or more 150-watt spotlights placed in opposite directions at equal distance from the subject would eliminate the highlight, halftones, core, reflected light, and cast-shadow sequence necessary to create convincing form. However, a single 150-watt spotlight used as the main light source and a 50-watt spot positioned on the opposite side of the subject, close enough to produce reflected light, would help to make the form convincing. The same result could be accomplished by taking a bulb of the same wattage as the main light and placing it three or four times the distance of the main light from the subject. A reflecting surface could also be used in lieu of the second light to create the same effect.

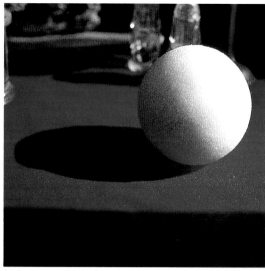

Light from a single direction creates a powerful contrast between high and low values and a strong cast shadow. These value principles illustrated on a simple ball apply to any object or grouping, no matter how complex their shapes and contours may be.

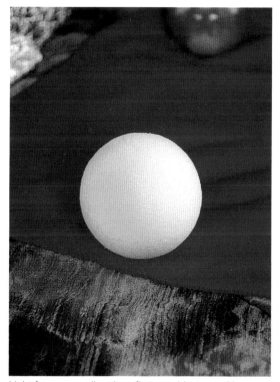

Light from many directions flattens objects, as this photograph of the same ball shows. Knowing this, when arranging lights on a still-life setup, you're best advised to use one dominant light source to create good contrasts of high and low value and emphasize volume.

ANGLE/DIRECTION

For giving three-dimensional illusion to an object, light should be strategically directed to play shadows on it. Let me restate: Too many equal light sources coming from many directions will have the opposite effect, making a form appear flat and two-dimensional.

The orientation of your light source is important for other critical reasons. Depending on its direction and strength, light can help build structure, emphasize specific areas or objects in a composition, or set a mood. The shapes of shadows, their axis direction, and what they overlap can pull parts of the picture together, unifying your composition. Shadows cast over other color forms also can enliven an otherwise dull area of a painting by producing additional color combinations within the shadow area.

Light from many directions creates a flat rather than round image even on a surface that has many planes, as on this sculpted head. A second, lower-intensity light source is needed to produce reflected light and a sense of volume.

Inspired by the great master, so-called Rembrandt lighting coming from above and slightly to one side uses a dominant light source with an additional subordinate light to emphasize form to its maximum.

An aluminum-foil reflector at right throws additional strong light into the shadow on the sculpted head to show evidence of structure into the previously too-dark shadow side. Working with a model head such as this, found in stores that sell painting and sculpting supplies, is great practice for life portraits you'll be painting in pastel.

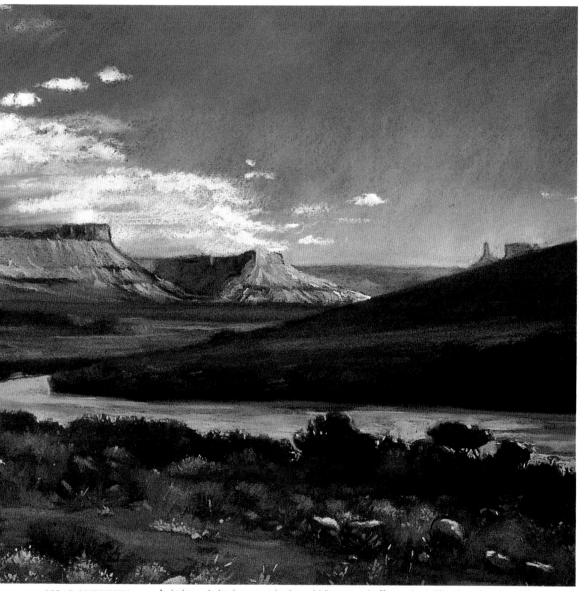

MOAB OUTSKIRTS
Pastel on paper, 15 × 23"
(38 × 58.4 cm).
Collection of the artist.

A darkened shadow area in the middle ground offsets the brilliantly colored and illuminated cliffs in the background of this sweeping vista. Cool blues and white of the sky find color kinship with the strip of water below, unifying the composition. The contrasting textures of stone in the background and low brush and flowers in the foreground are expressed through the different kinds of color strokes applied. This adds a necessary variety to the composition.

REFLECTED/ABSORBED LIGHT AND COLOR

Light rays traveling through space are bounced off many surfaces along their route. The source illuminates these reflecting surfaces and travels on to brighten others. As light travels, its intensity is lessened by the absorption of every object it falls upon.

Reflected light is absorbed in various degrees by the color, value, and texture of interrupting objects before being bounced on to another destination. For instance, a white surface will absorb a small percentage of light intensity, a black surface a large percentage. As the color value of the reflecting surface lowers, the amount of absorption increases and the reflective amount decreases proportionally.

Opacity and transparency are also affected by light. An opaque color reflects more light than a transparent one. Knowing this, artists will increase the amount and thickness of opaque colors used in the painting's center of interest. Conversely, transparent hues allow light to penetrate the top layer of color, keeping light "inside" rather than immediately reflecting back to the viewer's eye. This is an important point for the pastelist to remember when applying a thick, opaque, light-reflecting layer of pastel, versus a thin, transparent, light-penetrating one. Note, however, that all pastel colors are relatively opaque, because pastel manufacturers add white in varying amounts to pure color to produce the lighter pastel tints; the more white added, the more opaque the mixture becomes.

Light rays reflected from an object tend to acquire the hues of the reflecting object. For instance, light bounced off a red surface onto a white surface will produce a reddish-white surface. So, if you're doing a portrait of someone wearing a red shirt, notice and paint the reflection of pink cast under the model's chin.

I diagrammed this roughly to show how light penetrates color layers. A solid, opaque surface color reflects light to the eye; color appears bright. When physical light penetrates one layer (opaque and transparent), it continues through transparent layers until it hits an opaque layer, then reflects back through preceding layers to the eye, but is much weaker in intensity.

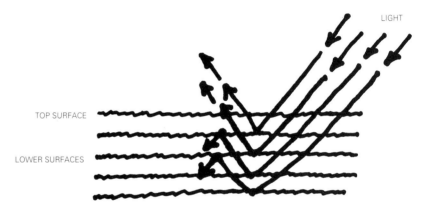

Light reflected and transmitted is illustrated by this photograph. Note the reflector of aluminum foil on the left positioned to reflect light.

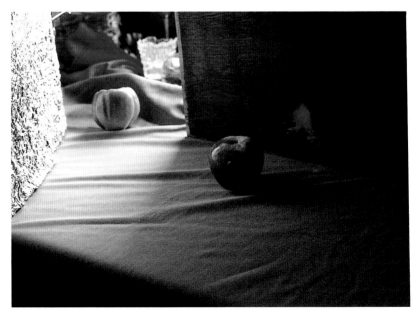

Form and Volume

Everything we draw or paint—an egg, a face, a tree—has not only a shape but also a form: something that's solid and occupies space. Once we know how to create simple forms, we move on to portray structures with more complex volume. The word *volume* in an artist's vocabulary refers to the illusion of solidity given to a form by the painter. And of course the presence of light, natural or artificial, will condition how your eye sees and your hand interprets form in your pastel art.

All great painting masters have been expert at reproducing volume. As a serious beginner, as you grasp, practice, and develop the very same foundation skills that guide the pros, you'll find image-making to be much easier and a lot more fun.

For starters, please keep in mind throughout our discussion of volume this most important point: *Volume is created by using a sequence of value changes. Every color has a range of value, and the simplest way to contemplate volume is by associating a color's value with the black-and-white value scale.*

So, let's start creating volume. As the progressive value steps are produced on the shape, the transformation from shape to volume takes place. First, to establish terminology, *flat value* refers to a value that remains constant over a part of a painting—often on flat planes or the sides of an object; *graded value* is an area that goes through a transition from dark to light or light to dark, building dimension, bending the plane into a contoured surface.

The easiest way to start producing form is by basing the object on a simple geometric solid form: an orange is first a sphere; a can of soda starts as a cylinder; a pine tree begins as a cone. Always draw the geometric form first, before evolving the image into a specific identity. This rule goes for all natural, organic shapes, including the human form, all parts of which can be reduced to basic geometric forms as starting points: a head begins as an orb; a torso as a cube; a leg as a cylinder, and so on.

Let's examine geometric solid forms individually, and their salient features as related to color value:

- **Sphere.** A sphere's surface revolves toward or away from the light source. There are no flat planes on a round object, so there are no flat values. If you're painting a human head or an orange, every area of its surface goes through a transition of value change.
- **Cylinder.** Some similarities are carried over from the sphere, since the body of a cylinder is round. However, its surface length, or parallel axis, is straight; a surface line stretching from end to end would be the same value along its whole length. Any curving area goes through continuous value change. Lines placed edge to edge encircling the form would show a series of value changes. The highlight, halftones, core, and reflected light originate and exist on these side-by-side surface axis lines.

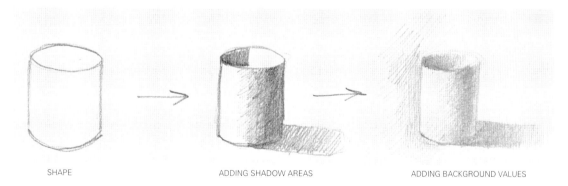

SHAPE ADDING SHADOW AREAS ADDING BACKGROUND VALUES

A flat shape becomes a rounded form the minute gradated shadow is placed within the simple cylindrical outline. Background value and a cast shadow give added reality to the picture.

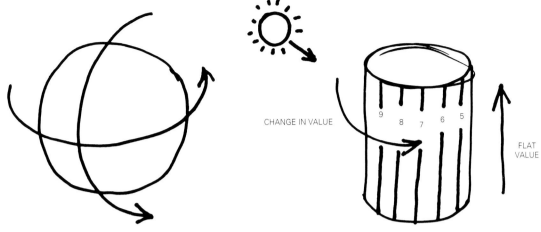

CONTINUAL SURFACE CHANGE IN VALUE

CHANGE IN VALUE

FLAT VALUE

A sphere goes through constant value changes. No matter how subtle they may be, both longitudinal and latitudinal gradations of color should occur over the entire surface for the form to appear realistic.

With light coming in from the left, a cylinder's color values would be highest on the left and gradually decrease around the curved form. Lengthwise, each value remains the same from the bottom to the top of the form.

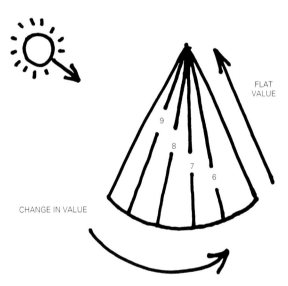

FLAT VALUE

CHANGE IN VALUE

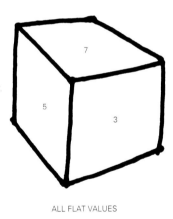

ALL FLAT VALUES

A light source from the left creates value modifications from high to low encircling a cone form. The lines parallel to the axis slant from base to point, but each color value remains flat along that line.

A flat and differing value occurs on each side of a cube. Those distinct differences help establish architecture when cubes become houses and other structures in landscape paintings.

- **Cone.** The cone is of course similar to the cylinder, but tapered at one end to form a point. The same transitions of value found on the cylinder exist on the cone as the eye travels around its form. If we magnified the top of the form, the value transition would still be there. This time, flat parallel-to-axis lines originate at the circular bottom and slant to a point at the top. The highlight, halftones, core, and reflected light continue to originate and exist on these axis lines.
- **Cube.** Of course, there are no curved surfaces to be interpreted, just flat planes, when you're painting shapes akin to cubes or rectangles. Therefore, you need only create distinctly flat and differing values for each side.

VALUE CHANGES ON A CUBE

To illustrate the last point, here's how you would paint a cube with three different, but close, flat-value planes. Imagine that the top receives the maximum amount of light (value nine); the side facing the light source receives glancing illumination, one step lower in value (value eight); the front, turned away from the light source, receives the least light, another step down (value seven). The cast shadow is darkest adjoining the form, where there's maximum blockage of light, and gradually becomes lighter in value until the evidence of shadow disappears.

VALUE CHANGES ON A SPHERE

Using longitude and latitude terms, let's suppose you're painting a ball. Starting with the area facing and closest to the light source, you give it a white highlight (value nine), temporarily calling it the "top pole." From there, drawing a line down to the other end, you create "latitude" lines connecting to the "bottom pole" 180 degrees from the highlight. If you draw equally spaced "longitude" lines connecting the poles down to the other end, each line would represent a value change on the sphere. Both the latitude and longitude lines become circular or curved, thereby providing clues as to the configuration and identity of the rounded surface. A rounded core line would indicate a volume or rounded form. The next line is the reflective light (value seven)—a little lighter in value than the core (value six), but never as light as the highlight.

The cast shadow in this example starts at the junction adjacent to the form (at value six) and dissipates by incremental degrees in all directions going away from the form until it disappears.

MORE TIPS ON COLOR, VALUE, AND LIGHT

Always try to include reflected light on a form. Its inclusion makes the form's volume more convincing than it would be with the core value at the edge. With the dark core value at the edge (without reflected light), it optically creates a forward-moving edge, rather than a receding one, thereby, destroying the illusion of volume.

Strong color or value contrast sets up tension in a painting. It dissociates and separates elements spatially. A weak contrast between elements brings them closer together spatially. Objects and elements that exhibit the same characteristics unite at the same position in space.

You'll develop forms more confidently in your painting if you block in shadows first, then work on in-between values. Producing a contrasting background value adjacent to the highlight area makes it easier to see and proceed than it would be if the background and highlight were to remain the same value.

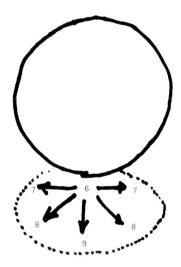

GRADATION OF CAST SHADOW VALUES

Relating to the value scale shown on page 32, the numbers marked show the gradation of cast-shadow values emanating from an orb receiving direct overhead lighting.

Illusion of Space

For your painting to have a sense of space, you must establish a foreground, middle ground, and background and distribute your subject matter so that it either recedes into the picture plane or advances toward the viewer. The ability of the artist to place objects convincingly is an essential skill to master. To discuss how, first let me define three words I'll be using a lot: *depth, space, contrast.* Here's what Webster's tells us:

Depth. "The distance from the top downward, from the surface inward, or from front to back; perspective, as in a painting."

Space. "A boundless three-dimensional extent in which objects have relative position and direction."

Contrast. "The effect of a striking difference, as in color or tone, of adjacent parts of a painting, photograph, etc."

DEPTH THROUGH LINEAR PERSPECTIVE

There are two ways of suggesting depth in your paintings. The first, which I'll just touch on briefly, is called *linear perspective.* This system uses real or implied lines converging at a vanishing point or points on the horizon or at eye-level, linking receding

BEAVER POND
Pastel on sandpaper,
11 × 14" (27.9 × 35.6 cm).
Collection of the artist.

While this is meant to be a close-up portrayal of an intimate, secluded little pond, an illusion of space is still created through the establishment of a foreground, middle ground, and background.

Although the sky doesn't show in my painting, a streak of brilliant sunshine peeping in from the upper right continues to skip over the water into the foreground, announcing the bright day it is. I blended this gorgeous mélange of violets, blues, greens, reds, oranges, and many more colors both physically and optically in an extensive series of layers.

planes as they go. The most classic illustration of this is the example of parallel lines of railroad track that seem to converge in the distance, forming an inverted V at a so-called vanishing point on the horizon. For the reader who wishes to delve more deeply into this subject, I recommend *Perspective Drawing Handbook* by Joseph D'Amelio (Tudor Publishing).

DEPTH THROUGH ATMOSPHERIC PERSPECTIVE

The other method of conveying depth in a painting is through atmospheric perspective (sometimes called aerial perspective), which is especially well suited to pastel work and the method I use most often in my paintings. Distance and depth are represented by the way the atmosphere affects the human eye. Outlines become less defined, details are lost, colors become paler and color contrasts less pronounced. Key words for atmospheric perspective are *reduction* and *diminution*. The maximums of any and all elements are presented in the foreground, while the minimum, or absence of elements, occurs in the background.

For example: In the foreground (the bottom portion of a painting), a tree clearly has a trunk, branches, leaves, color, value, and structure, while a tree in the background (toward the top of the painting) doesn't exhibit any of these properties except perhaps shape and dulled color, along with

VELVET FOG, TRAVERSE CITY
Pastel on paper, 18 × 24"
(45.7 × 60.9 cm).
Private collection.

Because color and form are reduced in intensity as they move farther away from the viewer, the paleness and ambiguity of the background treeline helps establish a sense of distance. This atmospheric perspective also causes outlines in the distance to become less defined, so that in this case, individual trees combine into one large, simple form. By contrast, the foreground shows texture and detail.

Highlights on the water becomes even more luminous in contrast to the pattern of dark reflected abstract shapes that flanks the bright streaks.

a reduction in size. Bright green foliage in the foreground would diminish to a very faint value of that hue on tree foliage in the background. Somewhere between foreground and background, a tree in the middle ground would exhibit half the properties of the foreground tree. The various spatial positions in between are regulated by the degree of total contrast reduction when compared with the foreground.

Another rule of atmospheric perspective to remember is that all spatial effects are comparisons. The more alike objects are in color, value, texture, and pattern, the more these objects will connect to each other at the same position in space. Objects unalike in characteristics separate from one another, with the form having the strongest or most characteristics "coming forward" in space, and the others seeming to recede. Increasing the disparity pushes the weaker element farther back into space.

The degree of contrast can also contribute to mood elements in a painting. The greater the differences between elements, the more tension and animation is likely to be felt. It works something like the "opposites repel, likes attract" premise.

Contrasts can be accomplished by adjusting any of the following: light, size, volume, value, color, intensity, temperature, texture, activity, shape, position, identity, description, and detail.

Overlapping is another very positive indication of spatial position and perspective. Regardless of its lack of strength or contrast, the object placed in front of the overlapped form should have essential characteristics of opacity and a defined silhouette contour. This is critical for creating the illusion of overlapping.

SOUTHERN EXPOSURE
Pastel on paper, 18 × 24"
(45.7 × 60.9 cm).
Collection of the artist.

Sun dappling through the trees created wonderful contrasts of light and shadow on rocks, water, and foliage in this woodland glade. Long strokes of white applied over dark colors layered beneath describe water rushing over the foreground rocks, bringing animation to an otherwise serene setting.

LIGHT AND SIZE GIVE DEPTH CLUES

Light produces all the clues that identify form, color, and structure, so, of course, reduction in the intensity of light reduces definition of subject matter. Complete absence of light relegates an object to a two-dimensional shape. Compared with three-dimensional form, two-dimensional shape is the weaker element, therefore decreases in importance and recedes back in visual space.

A standard size is generally assigned to recognizable objects, and the assumption is that these same objects that become progressively smaller in a painting must also be moving farther and farther back in space. The same type and age of trees, for instance, become smaller as they recede in space.

VOLUME AND VALUE ALTER DEPTH

Objects in the foreground contain all the information necessary to establish visual volume and structure. Systematic reduction or elimination of these characteristics would push these objects toward the background, relegating them to two-dimensional flat shapes existing in a two-dimensional background.

A wide range of value differences makes objects more structural, exciting, and frontal, sending them forward in space. A reduction of value contrast makes objects seem to recede in space.

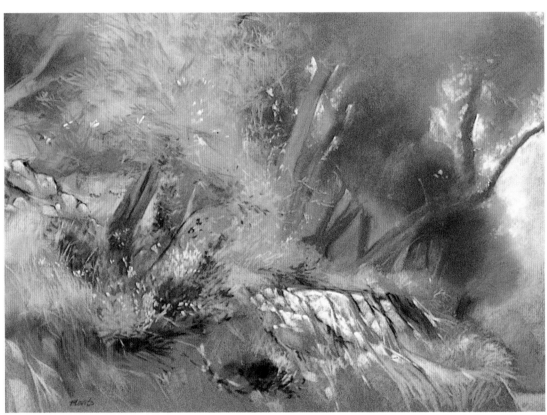

OLIVE GROVES, MORNING, SERIES #1
Pastel on paper,
16 × 22" (40.6 × 55.8 cm).
Private collection.

When the distinctive diagonal thrust of these trees caught my eye, I decided to make them a focal point by closing in and featuring their thin trunks. Bringing those cool grays to nearby rocks provided color variety. At lower right, I used a device for giving elevation to this rocky hillside and the impression of distance beyond it by simply adding a little square of misty color that suggests a peek at a body of water below, with a faint tree outline on its far shore.

COLOR INTENSITY AND ACTIVITY

The same premise holds true for colorful objects, which advance in space when compared with grayed-down, neutral, black, or white objects, which tend to recede. By *colorful,* I mean having a variety and range of hues.

If you experiment, you'll see that adding even a slight amount of complementary color lessens the intensity of a hue. This has the effect of making it recede somewhat next to nonadditive colors. So, while the brightest colors will read as foreground, when mixed with their complements, they become middle-ground or background objects, depending on their blend ratios.

Object colors related to background colors also recede. For example, if a background is grayish green, an object with that tone in its mixture will form a stronger attachment to the background, especially if it's of the same value, and optically sink into it.

Active and passive areas of a painting also contribute to spatial illusion. An area possessing many colors is more active, therefore advances in pictorial space as compared with passive areas containing only one or two colors. Where you make pure, direct, energetic marks with pastel sticks, that becomes an active, advancing area of your painting, whereas sections of rubbed or suppressed color will recede into pictorial space.

PIAZZA CARDUCCI
Pastel on paper, 18 × 24"
(45.7 × 60.9 cm).
Collection of Bob Hicks
and Suzanne Burke.

Looking through a shaded area that opens to a bright piazza, such as this one in Pietrasanta, Italy, always intrigues the viewer. And the juxtaposition of the light color values of a sun-drenched background with the dark values of a shaded foreground provides very inviting contrasts for the pastel painter. In this case, dappled light sneaking into the shade, the white street lines, and the splotches of sunlight in the middle of the street all unify the opposing value sectors. Note the variety and range of hues in the tree bark and in the signs and other elements on the wall to the right, making this an active area that advances in pictorial space. For the passive area, which recedes in space, I used only a few muted tones in the trees and building seen through the arch.

POSITION AND DETAIL

The eye-level line of a painting is an imagined line running across a composition, which the viewer uses as a reference to determine where the artist originally stood in relation to the subject shown. In landscape paintings, the eye-level line is often the horizon line, where sky and earth seem to meet—which is assumed to be the maximum distance in visual space. Therefore, there are spatial implications to the position of objects above, on, or below that line. At or near the line places objects in the distance, a typical example being pale mountains seen far off near the horizon line, across stretches of fields that move from the foreground to the middle ground. Placement of objects below the eye-level line or horizon line optically moves them closer to the viewer as the distance from object to horizon line increases.

Of course, the nearer an object is placed in the foreground, the more clarity and detail it should be given by the artist. Characteristics or identifying marks are easily observed in close objects while absent in those that are far away. Inexperienced artists often overlook this obvious fact and ascribe too much detail to subject matter that is much too distant to be seen clearly—such as the painting that shows hundreds of little leaves on a background tree when that tree is placed too near the distant horizon line to logically show such minute detail. Only a suggestion of overall foliage, not individual leaf patterns, would be seen at that distance and should be replicated that way by the artist.

SUN SPOTS
Pastel on paper,
16 × 22" (40.6 × 55.8 cm).
Collection of Jane Idema.

This nearly flat field has similarly colored trees of dark-value greens, with back lighting that filters through mainly in the foreground, giving the painting both its name and its golden highlights. In addition to working on white charcoal paper, I added many layers of a variety of dark greens and browns before placing lighter blends of green, mixed mostly from blues and yellows, on top. While I made the background blends fairly smooth, when I got to the middle ground and foreground, I wanted to give definition to the different grasses, so I used varying lengths of thin, vertically oriented pastel strokes to express their differing directions and textures. That little break or shadow in the lighter grass near the foreground—a dark line that runs a little uphill from right to left—provides good contrast against which some of my lightest yellow grasses pop forward. A stippled application of bright yellows—small dots and dabs of pastel forming tiny yellow blossoms shooting up in the middle ground—were put down as my final detail.

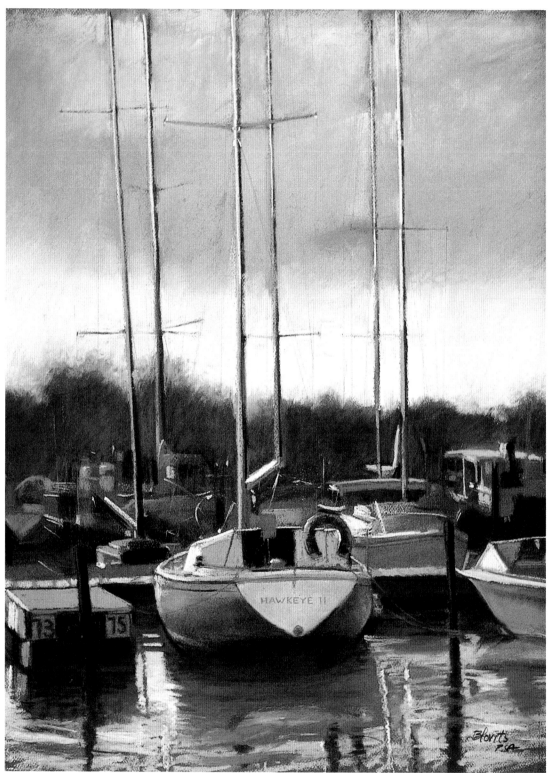

SOLITUDE
Pastel on paper, 24 × 18"
(60.9 × 45.7 cm).
Private collection.

The smooth blending of pastel colors is a technique that is especially useful when the artist wants to describe a certain feeling about the subject matter. The even-textured blending of color here allowed me to render lots of specific information about these sailboats and their soaring masts. A luscious sunset sky reflecting a rainbow of soft colors in the water seemed just made for a pastel painting.

But in the foreground, all identifying marks of an object may become crystal clear. Especially when the artist's style is very realistic, objects seen close up become almost photographically portrayed. Using a pool table for illustration, details in a foreground cue ball include value, reflective light and color, mirrored surface, evidence of chalk marks from the cue strokes, dirt, dust, a crack, and maybe a chip or two. The maximum detail clarity occurs in the center foreground of the cue ball: the closest position to the viewer. The cue ball's detail is decreased slightly as the form revolves from center to its edge. Any object behind the cue ball is reduced in detail according to its distance from the cue ball. Closer objects have almost the same degree of detail. Objects farther away show an elimination of detail. Of course, this is accompanied by a decrease in size, volume, and structure.

This photograph shows the sharpness of detail in the foreground pool ball and the gradual reduction of clarity with successive balls as they recede into the middle ground and background. Working with a still-life setup like this would be an excellent exercise to develop your skills in painting volume and atmospheric perspective.

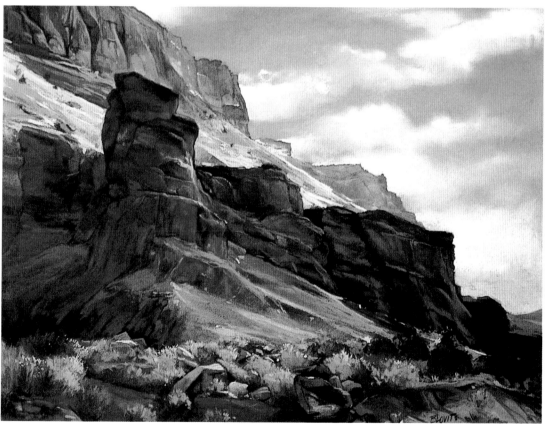

UTAHIAN II
Pastel on paper, 18 × 24"
(45.7 × 60.9 cm).
Private collection.

For this pastel of the Utah landscape, I chose a vantage point from which to capture the splendor of a great cliff, because I knew its stepped formation would make a strong diagonal composition. Almost slicing the painting in half colorwise, cool blues and white command the sky triangle on the right; warm, reddish earth tones dominate the triangle on the left. The goal was to produce the different inherent textures of each area in light and shade, and to balance the composition.

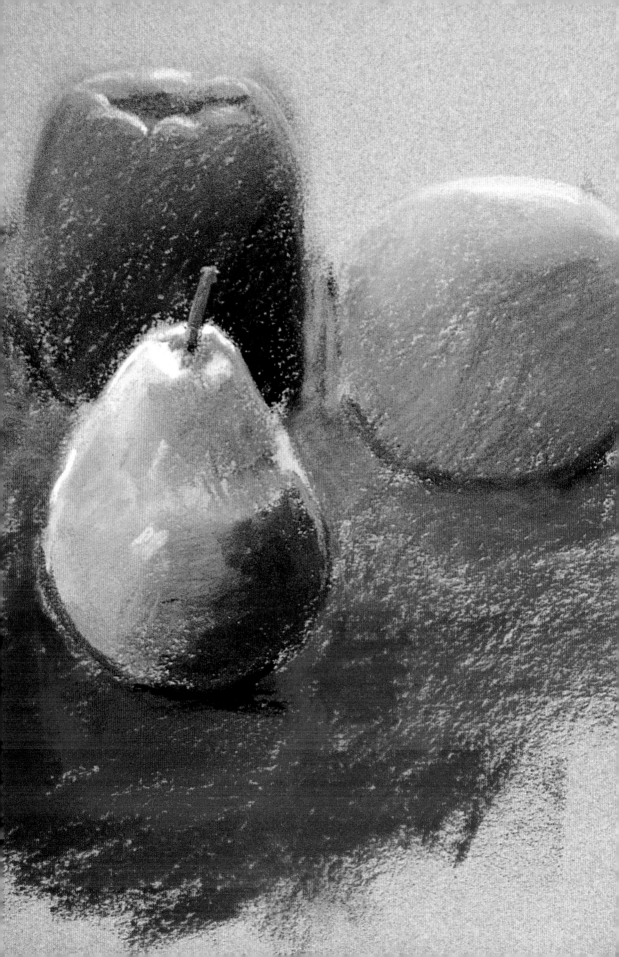

Getting Started

Now that you're familiar with the pastelist's materials and tools, and have reviewed the fundamentals of color, light, shadow, form, and volume, it's time to get down to specifics of technique and basic working procedures.

This chapter teaches how to handle both hard and soft pastels to get maximum and varied effects from each. Even though the pastels that you're getting ready to use may be a full set of exquisite colors, you'll soon discover the pleasures of extending that range even further through the blending and application techniques presented here.

How to proceed with composition, underpainting, and overpainting are discussed and illustrated next, with particular guidance on how to apply these methods when painting from life. For those occasions when working from photography is a practical alternative, this chapter also offers basic guidance for camera use as an artist's tool.

My hope is that you will use the technique instruction found here as a jumping-off point for further exploration on your own into the myriad expressive possibilities pastel art offers to creative beginners and professionals alike.

In this detail of a still-life sketch, note the variety of strokes I used to establish each object's form and texture. Note, too, how the bright, bold strokes of highlight color on the pear help make it come forward in the picture plane.

Technique

Perhaps the single most important thing that can be said about pastel technique is its flexibility.

Unlike other mediums, pastels can easily and continually be corrected during the working process without worrying about problems such as drying time (for oils) or retaining the paper's white surface (for watercolors). Even in the hands of experts, the creation of a pastel painting is in fact based on continual change, correction, and hiding of "mistakes" under new layers of color. Obviously, since revision is one its basic features, pastel painting is an ideal medium for beginners.

Another aspect of pastel's great flexibility is how well it lends itself to blending of hues that create subtle, gradated, and textured tones. Learning how to mix pastels not on a palette, as with other mediums, but on the working surface, is the first step to be learned.

HOW PASTELS ARE APPLIED AND MIXED

A pastel painting is produced by using a combination of marks or strokes of pure color on a receptive surface. Pastel marks are applied and combined in a variety of ways: hatched (fine, closely spaced parallel lines); cross-hatched (two sets of parallel lines placed across each other, usually at right angles); blended; blurred; overlapped; and rubbed. Each mark variation creates a different effect and performs a different function.

Strokes are applied with both the ends and sides of pastel sticks. Application pressure, light or heavy, affects the mark you make. A heavy pressure with the side or end of a pastel stick will completely cover up the underlying color. An intermediate or light pressure will either physically or optically combine with the overlapped colors to create new combinations.

- Upper left: Hatched strokes are closely spaced parallel lines.
- Upper right: Cross-hatched strokes are two or more sets of parallel lines placed across each other, often, but not always, at right angles.
- Lower left: A light hatching of blue over yellow produces this green.
- Lower right: A rubbing of the same blue over the same yellow produces a smoother green.

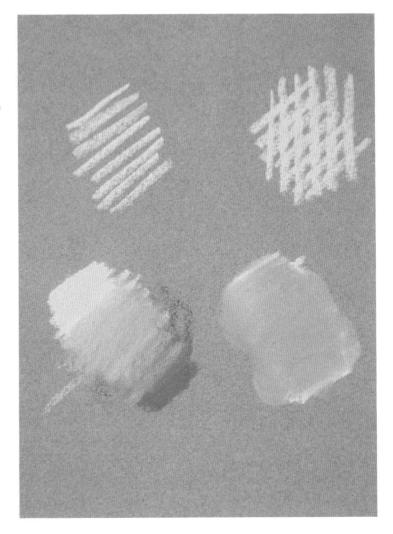

When using pastels that come wrapped in protective paper, artists often remove those sleeves so they can break the stick into usable lengths for creating various widths of strokes. The side of the pastel stick produces broader marks, allowing the artist to paint in larger masses of color. Hard and soft pastels are used interchangeably, but some application features are distinctive to each.

Hard Pastels

When hard pastel sticks are manufactured, sometimes an excess of binder migrates to the outside surface of the stick (especially true of NuPastel). Until that harder surface is worn away, it's difficult to apply pastel effortlessly—although every pastel paper has some abrasiveness to its surface, and eventually,

through use, the outer shell will be worn away, allowing for easier application. Once you get through this hard shell, pastel transfers freely to the paper surface.

An advantage of hard pastel versus soft is its usefulness for line drawing and fine detail work. Unlike soft pastel, hard pastel, particularly NuPastel, can be sharpened to a point using a new single-edged razor blade or an X-Acto knife. Place the pastel vertically with one end facing down in contact with the paper while keeping the numbered end facing up. To begin sharpening the stick, shave off one of the corner edges, cutting down with the razor blade. Repeat the procedure on all corners until the pastel is sharpened to a point. When the stick is almost used up, the number will still be there for reordering that color.

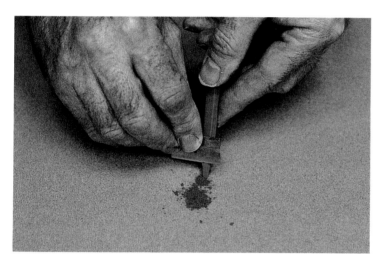

A new single-edged razor blade is the tool I prefer for sharpening my hard pastel sticks. In case you're not experienced with handling razor blades, let me emphasize that you should always shave in a downward direction, away from the hand that's holding the pastel stick.

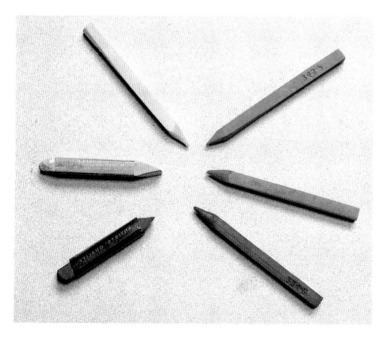

These Nu-Pastels, given good sharp points, are excellent for line drawing, fine detail work, and feathering (described later in these pages). Some artists point both ends, but by leaving one end square, you can still use the stick to make broad strokes of color.

Soft Pastels

Not only softer but also larger than hard pastels, soft pastels are powdery and accumulate to a thicker application on paper. Another difference is that soft pastels are manufactured in a greater range of tints and shades. They're excellent for application in broad sweeps to mass color in an area, or to apply in short, thick strokes.

While soft pastels usually crumble if sharpened, occasionally I've been able to create a chisel point with a few Grumbacher and Rembrandt pastels, which seem to contain more binder than some other brands. But even crumbled pastels are put to work by some artists, who use the loose particles to tone the paper. I think it's a waste of time. Use the intact stick for the mark you want to make, and get on with the drawing.

THREE BASIC TECHNIQUES

There are three general approaches to building a pastel painting. One thing that these methods have in common is the layering of color—the guiding principle of all pastel art.

Linear Approach

My usual procedure is to work from hard to soft pastel, beginning with my line drawing (which I call diagramming) in hard pastel, then using hard pastel to fill in color. The hard brands (NuPastel, Holbein) sit on the top surface of the paper and won't fill up the crevices, whereas soft pastel (Sennelier, Schmincke) will. Starting with hard pastels keeps my paper surface open, so more pastel can be applied later.

Block-In Approach

Instead of outlining objects in a composition first, many pastelists start by blocking in all the largest shapes with hard pastel applied in broad, massed strokes. Later, both hard and soft pastels are used to specify form, volume, and detail.

Atmospheric Approach

This technique integrates both line and mass to build color and volume. Vague areas of color are set down largely through cross-hatch drawings that build color areas for the viewer's eye to mix into definite shapes as the composition emerges.

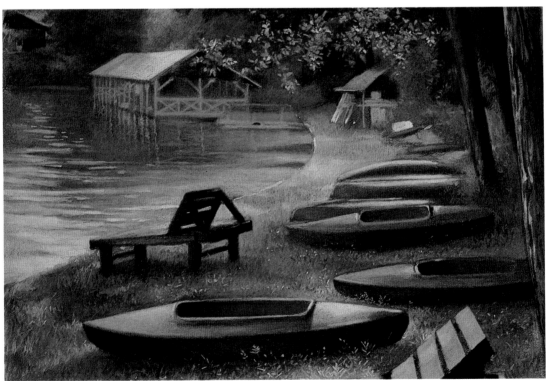

REST TIME
Pastel on paper, 18 × 24"
(45.7 × 60.9 cm).
Collection of the artist.

This scene offered not only a charming summer narrative but also an interesting play of strong complementary colors—red boats on green grass. I wanted to leave no doubt in the viewer's mind that these were bright red boats, but I did not apply flat red pastels to portray them. Careful layering and smooth blending of many reds with many greens produced dark brownish reds for the shadowed sides of the boats, while reds with white created the boats' light and shiny top surfaces, coordinated to white highlights on the water.

LAYERING

Whichever approach you choose—and why not try them all?—here are some principles about layering that are common to all pastel techniques.

You can rub pastel with your fingers, a tool, or a cloth to create flat, solid color, if you've applied enough pigment initially. A single color mass that you want to work into a smooth finish will be more effective if it doesn't reveal any characteristics of the paper—its grain, color, or value. Porous color will show the grain, which detracts the eye from reading the true pastel hue. Adding layers or pushing harder on the pastel stick will increase the impact and solidity of color. Apply as many layers as necessary, working them to an even, soft-focus finish.

When you are combining colors, because of its dulling effect, rubbing should be done only at an early stage; then that area may be recoated with new color (perhaps with workable fixative applied between layers) as the painting develops. But I consider the layering of different colors by rubbing desirable only for special, muted effects or to make a particular area recede in relation to nonrubbed areas. Rubbing throughout is not recommended because it sullies all colors, eliminating contrast, variety, and vitality. Let the strokes of one color over another do the blending instead. Your colors will stay cleaner and brighter.

TEXTURING

For blending colors optically into textured effects, here are the two most popular techniques.

Feathering

For producing a thin veil of color over another, feathering is accomplished by swinging the pastel stick very loosely on the diagonal, going back and forth, barely touching the surface. When used in portrait and figure paintings, feathering increases the luminosity of flesh tones and imparts a translucent quality.

Scumbling

This technique creates a rough, lively interaction of one color over another. Applied with the side of a pastel stick, the color is dragged lightly over an

This photograph illustrates a tip mentioned earlier when I gave pointers about paper in the chapter on materials.

When you use a flexible paper such as Canson Mi-Teintes, a surface that's clogged by excessive layers of pastel can be reopened by snapping your fingers against the paper surface. This jolts the pores open again and reestablishes the paper's tooth, so that more pastel can be applied right away.

This technique isn't possible with sandpaper; when that surface becomes "closed" to pastel, it is unresponsive to finger-snapping.

underlayer, never completely covering that color so that a broken, uneven application results. Light tones can go over dark or vice versa.

UNDERPAINTING MEDIUMS

Wonderful paintings are born from marriages of pastels to other mediums. If your background includes experience with handling other art forms, so much the better for putting that familiarity to work to expand your repertoire of pastel techniques. Here are some ways that other mediums are used as underpainting expedients for producing a color mass or solid ground.

Water-Based Paints

Since water mixes readily with pastel, any water-based painting medium can be used for underpainting in a wash state, be it watercolor, gouache, or acrylic. Acrylic requires additional water to assume the characteristics of a watercolor wash. Also note that since water swells the fibers of the paper, creating rolls and folds, lightweight paper must be soaked, stretched, and dried on a board first (just as you would do in watercolor painting). Or, to avoid that extra step, choose a heavyweight surface that won't warp, as long as the tooth of the paper remains open.

Oil

Oil color is acceptable for underpainting as long as it is thinned sufficiently with turpentine or mineral spirits to produce a wash. Oil pigment, used straight from the tube or thinned only slightly, will clog the pores of the paper, making pastel adhesion impossible. Turpentine doesn't swell paper fibers, helps keep the surface flat, and doesn't affect the paper adversely in any way at all. An oil wash dries fast and can be worked into with pastels almost immediately.

Charcoal

Vine charcoal, the softer of the two types made, is compatible with pastel; compressed charcoal is not. Because of its composition, compressed charcoal will clog paper pores, and is best avoided or used only by very experienced artists, who usually isolate the charcoal with a spray fixative.

WASH EFFECTS WITH WATER

Water can be added to any pastel to create a wash technique. Holbein has manufactured a water-soluble soft pastel made in a large heavy stick, individually cased. According to Holbein, "The water-soluble pastel offers the artist a medium with a pleasant feel capable of bold positive application. When dry, the pigments will have the same positive adhesion qualities as artist watercolor except there will be just enough surface pigment residue to give the soft visual surface sense of the traditional soft pastel."

Water can also be added to the pastel painting in progress to mix the unwanted color image into a neutral base color for revision purposes. Be careful to use a surface heavy enough to risk the distortion properties of water on paper. Sandpapers with a latex base such as Holbein's Sabertooth seem to respond beautifully to the wash technique without any warping. Other papers without a latex base would have to be stretched as a beginning preparation.

Working from Life

I encourage the serious beginner to work from nature, not from photographs, as consistently as possible. Whether your subject is animal, vegetable, or mineral, painting from nature will focus your attention and sharpen your powers of observation when you study light and shadow, shape and volume, color and texture as they exist in our three-dimensional world—not as interpreted by a two-dimensional photograph.

Looking at real life as you sketch and paint builds artistic skills by requiring you to think about and make decisions on size, proportion, color, value, composition, and all the other factors that will enliven your painting. Copying a photograph doesn't build any of these skills, because it's the photographer who selected or positioned the subject matter, perhaps engineered the light, and composed the picture. Even if *you* were the one who snapped the picture, it was the film lab that determined its color values (film dyes never exactly duplicate colors found in nature) and perhaps its cropping in printing it—choices that rob you, the artist, of important decisions that underlie the quality of your pastel painting.

NATURAL INTERRUPTIONS

Of course, working from life can present problems. If you're painting a landscape, cityscape, or seascape, changing weather conditions—movement of the sun, wind, rain, snow—sometimes makes it impossible to paint outdoors. Even on a perfectly beautiful summer day, mosquitoes may drive you away from your chosen setting (unless you've had the foresight to take insect repellent along—which, surely, you'll remember to do when you return to that setting the next day).

With these considerations in mind, the formation of many of my pastel paintings develop over an extended period of controlled time. When confronted with changing weather conditions, my landscapes are usually completed in the studio.

YOSEMITE MORN
Pastel on paper, 19 × 25"
(48.3 × 63.5 cm).
Collection of the artist.

I find early morning light as it dapples the trees, water, and rocks in the landscape very compelling. In this painting, a scene I came upon during a trip to Yosemite National Park in California, I strove to convey that feeling of light, working quickly to capture the fleeting patterns of sunlight and shade and using contrasting deep shadows to complement and strengthen the effect.

PLAN AHEAD

Indoors, too, nature can be fickle: flowers wilt, and so do people when they pose for long periods. The artist adjusts to these conditions accordingly and modifies the creative sequence.

A floral still life may require you to concentrate first only on the blossoms while they're at their freshest, detailing other elements—stems, leaves, vase, etc.—later, as the painting progresses. Likewise, the most perishable fruit and vegetables in a still life should be your first order of business.

Planning ahead also means making broad decisions about a painting before proceeding. Before

I actually begin sketching for a pastel painting, I write down particulars, noting light type and direction, contrast of values and colors, and any other pertinent information—and stick with those criteria from start to finish. So even when natural light and weather conditions change before my work is completed, those elements won't have to change in my painting.

The great masters succeeded in capturing a certain moment, light, and weather condition on canvas by rigidly adhering to strict artistic decisions. We can learn and profit from their experience by staying with one format until completion.

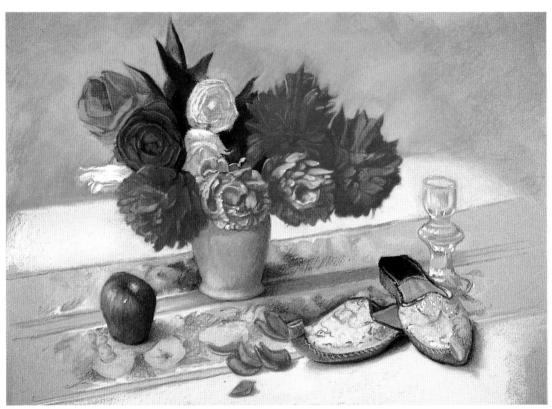

PEONIES WITH ORIENTAL SLIPPERS
Pastel on paper, 18 × 24"
(45.7 × 60.9 cm).
Collection of the artist.

Knowing that the peonies would gradually begin to droop, I concentrated on them first, taking notes about their color, structure, and the interplay of light and shadow on them while they were still fresh. Though the cloth pattern, slippers, candlestick, and other elements were important to the overall composition, developing them was of less immediate concern than capturing the flowers in their full glory.

Photography as a Reference Tool

Despite my urging that you paint from nature, sometimes you may be forced to rely on photographs for follow-up reference, when nature painting becomes unmanageable, such as under adverse weather conditions.

Other reasons that photography may be useful relate to portrait work. Folds in a model's dress or shirt change every time the poser takes a break, are often impossible to replicate, and a tedious waste of both artist and model's time trying to do so. Working from a quality photograph taken at the first sitting saves you the frustration of having to restructure the folds after every recess, and also saves you money if you're paying model fees. Use valuable posing time to work on other areas of the painting instead.

Special circumstances (perhaps a sitter's unavailability for extended sessions) may also require photographing the model and working from those shots for most of the painting process—as would also be the case if the subject is a baby or small child, who cannot be expected to sustain a pose.

Artists are often forced to work with someone else's photograph, as in the case of a posthumous portrait. The artist evaluates the source material, decides whether the photo is adequate, and uses both creative license and logic to produce the desired end product.

There are additional ways that photography can be the artist's ally. Sometimes I'll use an old Polaroid camera loaded with black-and-white film to evaluate a scene, pose, or halfway-completed painting. Mostly, I use it to check my values. The Polaroid produces an unbiased and instant photograph to study at my leisure. Since the old-style Polaroid camera can be used with or without flash, I can duplicate the light and evaluate the black-and-white composition without being seduced by color. Another way to check the value ratio in your work is to view your painting through a red gelatin filter (purchased at a camera store), which will convert all the color values to red.

CAMERA CHOICE

If you're inexperienced with cameras, don't own one, but plan to acquire one for use as discussed here, the ideal 35mm single-lens reflex camera for the artist includes manual settings, along with a depth-of-field preview button, self-timer, interchangeable bayonet-type lens capabilities, and a built-in averaging light meter with adjustable settings.

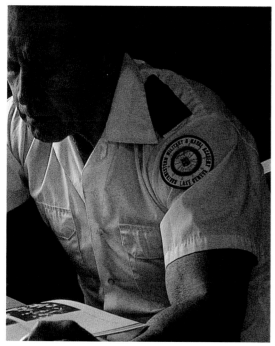

The photo of these shirtsleeve folds, taken at a first sitting, was an indispensable reference for follow-up work on this man's portrait.

I still worked from life in developing his portrait over several sittings, but not always having to restructure fabric folds saved lots of time.

The lenses recommended are 100 to 135mm telephoto for portraiture, 50mm for average pictures, and 35mm wide-angle lens for landscapes. Lens costs may be cut by buying a telephoto lens that starts at 35mm and goes to the telephoto distance desired, therefore including all the needed functions in one lens instead of three. A sturdy tripod is a helpful accessory.

In terms of gauging light on your subject, the camera has a built-in averaging meter that averages all values to a middle gray. It interprets light intensity in readings of black, white, and gray values only, no color. For example, a white wall filling the viewfinder (the eyepiece you look through) would be averaged to correspond as a middle-gray value. A black-and-white checkered wall would turn out perfectly balanced, because it's half white and half black, equaling a middle gray.

CAMERA EYE VERSUS HUMAN EYE

Without venturing further into the subject of photography, which is beyond the scope of this book, if you do use a camera for assistance in working on your pastel paintings, here are some general tips:

- Remember to place the camera lens at the exact same height and position of your eye as it is when viewing the subject while painting. Any deviation from this camera/eye position will result in a different angle in the photo, requiring numerous adjustments in your painting image to duplicate the new photographic viewpoint.

- When working from a photo, resist the natural inclination to replicate everything in the picture as is, regardless of the lens distortion or flattening of space. A two-dimensional camera image encourages duplication of that absence of space in the painting. The same response might occur if the picture were out of focus. Be careful to recognize and correct photographic deficiencies so as to not repeat them in your painting.

- Allow yourself the prerogative of replacing and revising objects in your photo reference when it suits your creative instincts as your painting evolves. Particularly where color is concerned, since the soft, diffused look of pastel differs from the sharp, flat colors that come through in photos, your good judgment and reference back to the living source should override camera impressions and guide color blending and other choices you make as you paint.

This detail of a landscape photograph shows very muted colors. Deciding to paint this scene, I knew I wanted to give it a more lively palette.

I took the artistic liberty of brightening the foreground and middle ground particularly, painting with much stronger colors than had nature.

Basic Working Procedure

The development of a work of art is a step-by-step procedure. Here is the general sequence I recommend to provide you with greatest flexibility and freedom during the development of your pastel painting. All of these phases will be expanded on in the chapters ahead, when we get to actual step-by-step demonstrations with illustrations for each step in still lifes, landscapes, and portraits.

START WITH SHAPE OUTLINE

Using a hard pastel in a neutral color (such as pale brown), I begin by sketching preliminary shapes that represent the main elements in my picture. In this step, I'm simultaneously composing my painting—giving each object its position, relating objects to one another in terms of their general size and placement.

Never draw details at the start. Use preliminary shapes only to identify category: a conical shape becomes a tree later, and much later, in your final step, details will describe a particular oak tree (old and decrepit, two limbs damaged by lightning, a squirrel perched on the third branch up).

DETERMINE THE CENTER OF INTEREST

Normally, the area that catches the viewer's eye first in the finished painting is the center of interest. Even at this early stage, have in mind where that will be—what it is that attracted you to this subject and that you'd like the viewer to observe first. Light can emphasize this focal point and most often does; so can clarity, detail, or color significance—all of which will be developed later. But that objective should guide all your choices as you proceed.

The largest shapes are sketched in first, using very freely drawn, preliminary shapes. A vertical composition is immediately established, as is a focal point, slightly off center to the left, where the largest shape will become a bright bush.

The first colors I block in are merely for general placement of color values, not for specific hues, which will continue to change as I layer. For now, these shorthand color notes tell me that I'll have darker values where the browns are placed, lighter values where I've set down blue. I usually make these first applications with hard pastels, using the sides of the sticks applied in broad strokes.

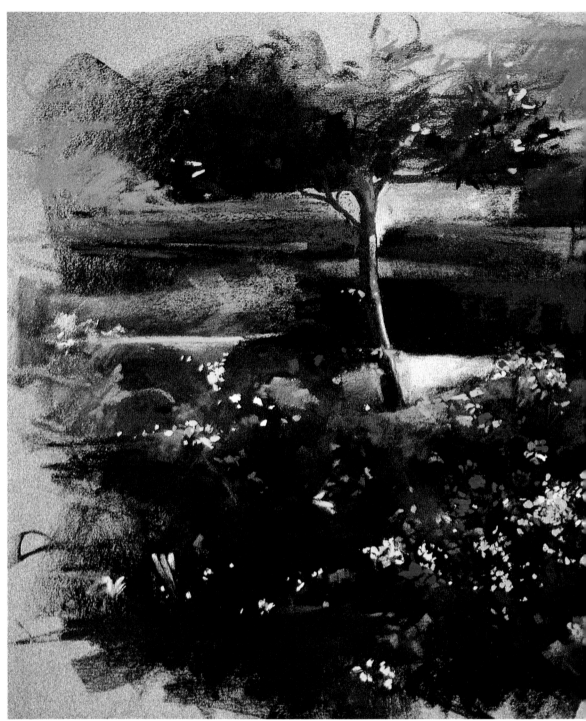

GETTY'S FOLLY
Pastel on paper, 18 × 24"
(45.7 × 60.9 cm).
Private collection.

This pastel started intentionally as an abstract pattern—with blue, pink, orange, and green horizontal color swaths in the background—as I built up layers of hues. Instead of layering over or blending the colors into a more traditional landscape background, I chose to leave them alone and use that sort of spontaneity as the standard for the entire painting. That's why I decided not to finish off the edges of the composition, which I thought would be more compatible with the freer, semi-abstract flavor that continued to evolve. However, going with a looser style doesn't mean losing control of color distribution, textural finishes, and other design decisions, which can be just as deliberate in abstracted as in very realistic renditions of nature—a point that is illustrated by my carefully balanced final short strokes of saturated yellows and reds in the foreground.

COLOR BLOCKING

Lay down simple color masses to indicate their general placement. I generally use hard pastel first, because it doesn't close the pores of the paper as readily as soft pastels. Remember, your color choice in the beginning isn't always accurate, but that doesn't matter. Make your best choice, then reevaluate. The colors you see when looking at your subject are not composed of just one hue, but a blend of many. There is no artistic way to produce these variations in the first layer of pastel. This mixture becomes apparent as you add and revise with transparent and opaque layers of color.

WORK FROM DARK TO LIGHT

Using the side of the pastel stick, first place large, general strokes of the darkest color values you see. Establish the middle values next, and finally, end up at the lightest color values. For example, a tree shape has both a light-value yellow and a medium-value green as part of its color makeup. Start the simple block-in with the green.

Don't worry about applying exactly the right colors at the beginning. When you think you see a specific color, put it down without question, but if it's wrong, that's no problem. Eventually, you'll come up with the right one.

A second meaning of "working from dark to light" refers to working darker than you think the color is originally. The tendency of beginners is to make colors lighter than they are in reality. Therefore, when revisions are made in progressive steps, the beginning color is revised lighter and lighter until it's too light. Starting darker sets color impact and intensity, provides contrast for the revisions, and keeps values from becoming too light and chalky. One variation in this procedure is to make the darkest color a little lighter so you can revise both darker (for shadows) and lighter in the building process. If you choose to use workable fixative, it should be sprayed sparingly between layers along the way.

REDRAWING

Building a composition should be in stages of development, each stage an incremental improvement over the previous one. Every object goes from shape to form to specific identity. Never hesitate to correct and redraw contours and edges. But be aware that when you redraw one part of the composition, the artwork's previous context has been changed, and remaining parts may have to be revised to coordinate with the new context.

As you leave yourself open to make changes for the betterment of the drawing, never let one area become precious and off limits. Give yourself permission to revise any part of the drawing at any time. This philosophy keeps the drawing fluid and the artist free and uninhibited.

To quote John Howard Sanden, an eminent New York portrait artist, "The amateur can't wait to finish the picture. The professional, on the other hand, can't wait to find out what's wrong with the painting." Concern yourself with how well you're producing the forms, not how fast you're completing the painting.

REPAINTING

Just as with redrawing, don't hesitate to repaint colors, even in advanced stages of your painting. The shifting back and forth of color by adding supplemental layers helps the artist to identify fleeting shades and tones. Trial-and-error application will improve your powers of observation and discernment of color. Slight nuances are not easily and accurately observed in the beginning, but such intricate combinations are often achieved through this revision process. As color combinations become more complex, you'll become more aware of their subtle variations.

When uncertain of color selection in putting one hue over another, I'll start out with light-pressure hatching strokes to get a sense of what the color relationship may be. If it looks good, or close, I'll increase the pressure slightly and cross-hatch until satisfied with both color and density. If it doesn't look like my color choice is going to work, I'll stop using that pastel stick immediately.

As discussed in an earlier chapter, it's germane to reiterate here that color is affected by its neighboring hue. Put a yellow alongside a blue and its border will look green. Put a small patch of yellow inside a larger area of violet and the yellow area will look grayish. It's important to establish the drawing's entire color field in order to evaluate and respond with corrective revisions. Only when you have all the color values established on the surface can you compare and decide whether each color is the right hue, value, or intensity.

COLOR SOLIDITY

Applying additional layers of pastel reinforces color choice, and solidifies and increases the intensity of color. Nothing is more disconcerting than rough texture or grain produced by porous color. A solid area of color is much easier to work on, shows nuances and subtleties clearly, and takes corrections more smoothly. If you want contrast between solid and porous color, it can be added at the end of the building process.

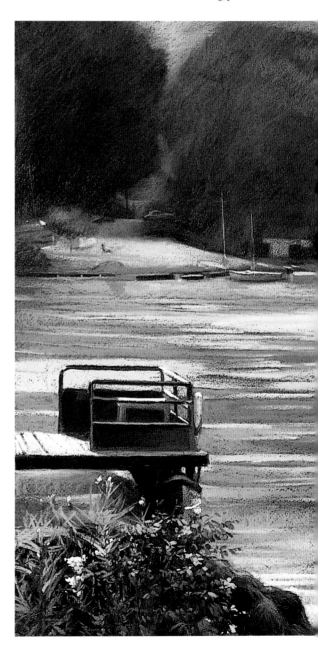

The pastelist cannot tell what the color composition will look like until all the surface is painted in whatever way possible. At that point, step back, evaluate, and continue to revise if necessary.

ADDING DETAIL

Through many revisions, you've worked your shapes into forms by adding gradations of tone and shade to give perspective to surfaces and volume to objects. Now you're ready for the final stages: adding descriptive information and detail as needed on the foundations of color and value established for all objects and surfaces in the composition.

Ironically, detail is often the very first thing an inexperienced artist wants to work on. But detail is a very firm commitment, and most artists, particularly beginners, are reluctant to change anything once it's been carefully, even painstakingly, set down. Avoid that trap by saving details for last, when you'll feel freer to make required changes. This is one of the most important pieces of advice I can offer you.

To sum up: A pastel drawing is constantly evolving and will only look right when everything is transformed into the correct proportion, form, value, description, color, and detail.

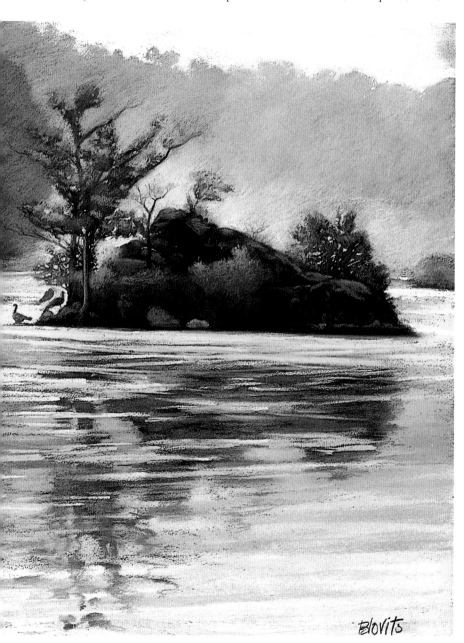

RIDGEFIELD LAKE
Pastel on paper, 19 × 25"
(48.3 × 63.5 cm).
Private collection.

Long, linear strokes of pastel describe the flow of water in this mirrorlike lake. Breaking into the strong horizontal orientation of those strokes is the verticality of the straight tree trunks and their reflection in the water. A strong value pattern is established by contrasting the deep greens and browns of the little island against the light blues, greens, pinks, and white of the water. While the island is the primary focal point that draws the viewer's eye first. Related values in the wharf at lower left establish compositional balance and visual entry into the picture plane, reading from left to right as the Western eye is accustomed to do.

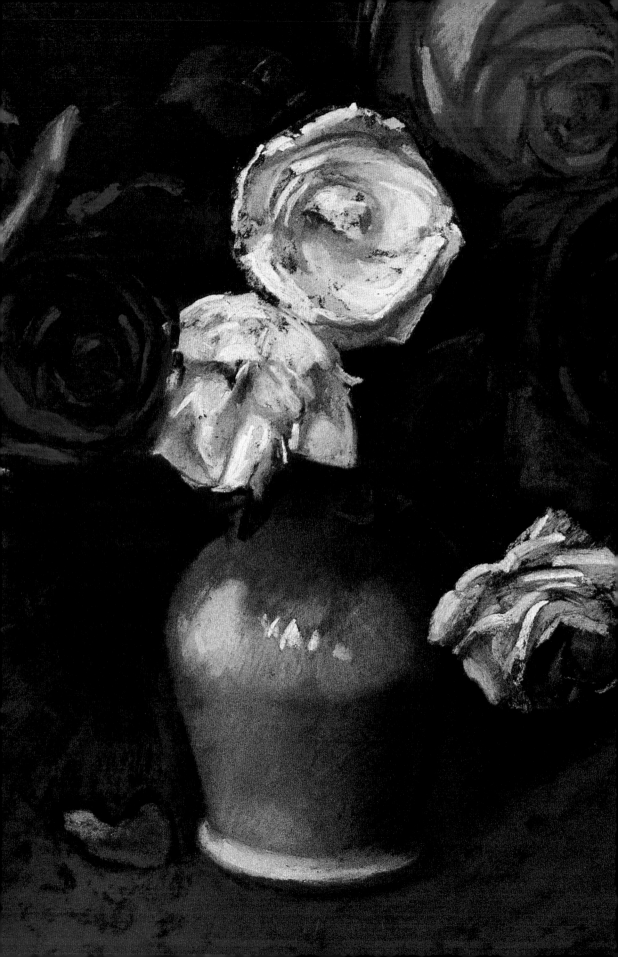

Still Life

"A picture consisting of inanimate objects" is the dictionary definition of *still life*. But in the hands of a creative artist, even inanimate objects—flowers, fruit, pottery, textiles, tableware—as they are brought together for their pleasing contrasts of size, shape, color, and texture, can make a lively, vital pastel painting.

In many ways, a still life is the most personal of painting subjects, because items can be selected that have special meaning to the artist: a family-heirloom teapot, an antique table, a child's favorite toy. Still-life painting also allows the artist to exercise creative control over lighting and mood. For example, an arrangement may be given very sunny lighting to establish an upbeat feeling, while very low-key illumination lends an aura of mystery or drama to a painting.

I recommend that your first pastel creations be still lifes. Since you won't be at the mercy of weather conditions for landscapes or a poser's availability for portrait or figural work, if you choose still life to launch your work in this medium, as a serious beginner, you'll have a good opportunity to build up your basic skills by practicing on a regular basis—I hope for at least several hours a week.

ROSES
Pastel on sandpaper, 9 × 11"
(22.9 × 27.9 cm).
Collection of the artist.

I decided on an unconventional placement for this floral still life by closing in tightly and cropping the roses at the top, left, and right. Somehow, I thought that these unusually large and beautiful roses demanded the attention that such close-up treatment would give them. Using a very dark background and surrounding the white roses with reds and pinks brought the whole bouquet forward even more.

Composition

To keep your composition exciting and challenging, be inventive in picking objects of different size, shape, color, and texture. You may include more than one—even multiples of an item—but be careful to avoid monotonous use of any element. While repetition does help to unify a composition, too much of the same thing makes it boring. On the other hand, be careful not to let variety itself become a boring repetition. It's a balancing act.

VARIETY

For example, objects of the same width or height can make for a dull composition. By including a few larger or smaller objects, the sameness is broken. A composition of similar objects, such as hard-boiled eggs, containing half and quarter pieces as well as whole eggs, is far more interesting than a composition of whole eggs only. Add a knife and dish and it's even better yet.

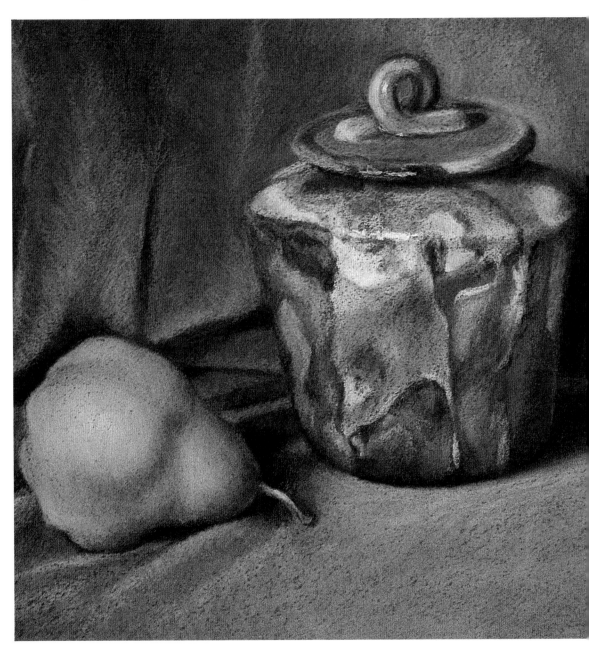

The artist can also modify form types, from simple to complex, as well as texture, color, line, placement, and description—anything that brings diversity to the composition also brings visual excitement.

BALANCE

All parts of a pastel composition—marks, colors, shapes, forms, values, textures—possess visual, and implied physical, weight. Balance is achieved when all these elements are arranged so as to create an overall stability.

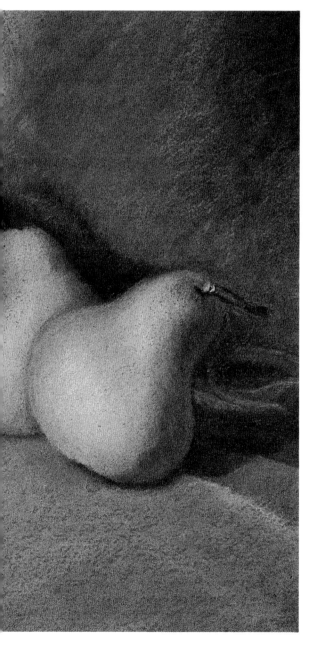

There are two broad categories of balance: symmetrical and asymmetrical. In symmetry, or equal balance, whatever occurs on the left side is mirrored on the right side; in asymmetry, or imbalance, whatever occurs on one side is counterbalanced by different elements on the other side. The latter is the customary choice for the artist, because it's less static and much more interesting to look at.

To create counterbalance, let's begin by thinking of a teeter-totter format with objects arranged on either side of the center fulcrum. Each side is influenced by the amount of contrast present. For instance, white balls of equal size and position on either side of the fulcrum balance each other. The implied physical weight is the same. Move one ball closer to the center, and the balance is shifted to the opposite side. Shifting the position of the other ball closer to the center rebalances the composition. Add color to one of the balls, and visual weight is added to physical weight, making that side heavier than the other side. Balance on the opposite side can be achieved by adding a similar or different color of equal visual weight, or by adding another ball (physical weight). This balancing act continues to change and requires adjustments throughout the evolution of the painting, from start to finish.

To illustrate further: A white ball doesn't possess as much visual weight as a brilliant red ball of the same size. However, the physical weight of a large white ball may visually balance with a small red ball that has both visual and physical weight.

In other words, the number of objects on one side of the composition forms a collective visual and physical weight that needs to be countered or offset by combinations of collective equal weight on the other side. Weight also increases or decreases as contrast elements are emphasized or diminished.

RAKU AND PEARS
Lauri Blovits
Pastel on paper, 11 × 18"
(27.9 × 45.7 cm).
Collection of Larry Blovits.

This appealing still life created by my daughter Lauri illustrates the principles reviewed above: her choice of a variety of objects and an asymmetrical arrangement that she has balanced well. The golden glow of the pears is echoed in the warm tones of the glazed pattern on the Japanese-style raku vase, and again in both background and tabletop color blends.

Dimensional Format

Up until now, this book has implied or specifically instructed the artist to portray objects with form and volume as realistically as possible. However, not all pastel painting must be figurative or representational art. You, the artist, have the freedom to decide the format and create a composition of your own choosing. It's not imperative that you reproduce nature every time. You might opt instead to paint in a purely decorative, two-dimensional format, which eliminates all possible spatial clues. Making this decision sets your goal and direction for the life of the painting.

TWO-DIMENSIONAL FORMAT
Color is applied flatly in a two-dimensional, graphic work of art. There is no attempt to give form and volume to objects or their setting. That is, there is height and width, but no depth within the composition. While it's almost impossible to eliminate all spatial indications, artists with that aim do their best to suppress the maximum number of clues, and work more on flattening space than producing it. Other relationships—tone, color, texture—are more important. Therefore, for this approach, all spatial factors introduced earlier in these pages are not pertinent.

THREE-DIMENSIONAL FORMAT
In selecting this format, the artist uses every spatial device and contrast possible to create the traditional requirements of a realistic work of art: foreground, middle ground, and background, with individual objects given chiaroscuro effects—light and shadow to create contour and volume. All of the information presented in earlier chapters related to this format is applicable to still-life paintings, as it is to landscape, figure, and portrait painting, to be discussed later in this book.

Whatever selection you make regarding dimensional format, the composition should be plausible. The artistic knowledge of how to create both dimensions is indispensable. In fact, you certainly have the freedom to combine two- and three-dimensional clues in the same composition. After all, pastel paintings can be created in any style or technique, from abstraction to realism, according to the painter's choice, as long as the following is kept in mind: Style and technique are integral to any work of art, but are not the sole justification for the artistic statement's success. Too many painters think a clever technique justifies ineptitude or compensates for lack of skills. The serious beginner should know that it does not.

This detail is a style of three-dimensional format that more than any other aims to describe forms, textures, and surface patterns in the most exacting replication the pastel medium will allow. The opalescence and decorative molding of the glass lamp, the patina of its metal trim, the painting of its floral design are all achieved with painstaking attention to very smoothly blended pastel application. The other object seen in this detail is a section of an afghan on a sofa next to the lamp table. The texturing of the crocheted wool, the direction of each of its thick stitches, its openwork border, and its repeat pattern are all rendered with meticulous precision.

The serious beginner who wants to pursue this "photo realism" style should do small practice studies of intricately designed objects such as these, using finely sharpened hard pastels.

Diagramming

In drawing the preliminary outlines for a still life, the first step is to decide on the placement of objects within the picture plane, beginning with the size and configuration of the first shape, which I call the primary object. Proportion considerations are height and width only. To measure proportions, follow these procedures.

PLACE THE PRIMARY OBJECT

From your easel or drawing position, extend and straighten your arm, locking the elbow, and hold a measuring stick (pencil or ruler) in a vertical position perpendicular to the axis of the arm. With one eye closed, visually "place" the top of your measuring tool on the top of the primary object in your still-life composition. While keeping the top position in place, slide your thumbnail down and line it up with the bottom edge of the primary object. This is the height proportion measurement. Holding the same measurements with the thumb position on the measuring tool intact, and with your arm extended and locked, rotate your hand to a horizontal position, keeping the pencil perpendicular

to the axis of your arm. Place the previous "top" end on the left edge (for a right-hander) of the primary object and compare your thumb position to the object's right edge. You're comparing the height to the width to discover the correct proportion ratio of this primary object. For example, the height may be twice the length of the width; therefore you have a two-to-one ratio.

You then place any desired length line on the picture plane for the vertical to make the width half the length. Therefore, the lines on the picture plane coincide proportionally to measurements taken from the original object. The size of the object produced on the drawing surface is strictly arbitrary and can be any size, as long as it has the same proportion ratio as the original—the height being twice the length of the width. For example, if the height measurement is actually two inches, and the arbitrary height of the drawn shape is made four inches, the drawn shape is twice the height of the original measurement. So the width (half the length ratio) should be made two inches on the paper surface—twice the width ratio of the original measurement.

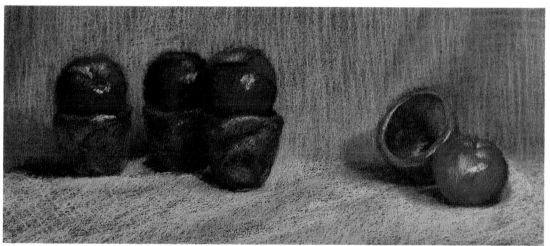

APPLES AND RAKU
Lauri Blovits
Pastel on paper, 9 × 20"
(22.9 × 40.6 cm).
Collection of Larry Blovits.

Small blue earthenware cups from a Japanese raku tea set become display stands holding bright red apples in this playful still life conceived by my daughter Lauri. When all of the objects in a composition are similar, variety can be introduced by placing them irregularly within the picture plane, as has been accomplished here. One of the pleasures of creating still lifes is personalizing subject matter by selecting objects that have special meaning for the artist or the person to whom the painting will be given.

RELATE ALL OBJECTS TO THE PRIMARY ONE

Once the size of the primary shape is established on the drawing surface, all additional shapes and forms added to the composition must be first compared with the original object's measurements, and proportioned accordingly when transposed to the drawn composition. For example, when compared with the original proportion measurements, the second still-life object is found to be three times higher and twice as wide as the primary object measured. Therefore, since you made the primary object drawn on the paper four inches high and two inches wide, the second object, measured to be three times higher, should be made twelve inches high and four inches wide (twice as wide as the primary object's measurements).

To be successful in transferring what you see to the painting surface, everything else added to the drawn composition—even negative spaces between objects—follows the same comparison and proportion formula as outlined above. Don't take anything for granted. Measure everything.

This procedure—measuring all items as related to the primary—is similar to the scale at the bottom of an architect's rendering—one inch equals one foot—in the actual building of the house. In the artist's scenario, one "inch" on the pencil might translate to three inches on the paper surface.

In measuring height and width in a two-dimensional format, any surface receding in space is still measured vertically and horizontally, never obliquely. The measurement of the top surface of a cube (from front edge to back edge) is evaluated vertically as a flat shape rather than a three-dimensional surface receding obliquely into space. From our daily observation, we know a rectangular place mat is almost as high as it is wide, but optically, it may measure much shorter than expected. The artist should accept this measurement and transfer it to the drawing surface without question. We're drawing an optical illusion of a table existing in space, not its actual length and width. The rule for the beginning artist is *measure!* When accuracy is required as the goal of the composition, the professional always measures.

This same procedure is used for all subject matter, not only still life but also landscape, portrait, figural—no matter what. Taking a measurement for granted without measuring is a mistake, and a bad drawing habit. Proportion will be off, and the drawing will suffer because of it.

Measuring my still life showed me that its height and width were equal. I lightly sketched a square outline on the paper and positioned the still life inside it, using the square border as a guideline for the placement of each flower. I blocked in the background color with the side of the pastel stick and brushed over it with turpentine to create a solid wash. Following procedure, I then started to fill in the dark values first.

ROSES IN VIOLET
Pastel on sandpaper,
14 × 11"
(35.6 × 27.9 cm).
Collection of the artist.

As work progressed, I continually searched my pastel sets for the elusive reds and violets I saw in my mind's eye. I made many changes, using workable fixative to areas where I needed to apply more color without disturbing existing layers and adding some delicate strokes to the flowers here and there with Conté pastel pencils. Finally, I adjusted the composition's foreground and background to provide more contrast to the flowers.

Lighting a Still Life

Decide at the outset what type of lighting will be used: diffused or concentrated? Also determine the specific direction from which the main light originates. A light source from above and projected slightly from the side will produce a clear distinction between darks and lights cast on objects in your still life, whereas frontal lighting may eliminate all the important shadows that help to produce the illusion of form.

OTHER VISUAL AIDS

The human eye doesn't always accurately tell the artist what's being observed. Visual aids that are superimposed over a still life, such as vertical (plumb), horizontal, and angle lines guide the artist in many ways: judging placement, alignment, angle degree, whether an edge is straight, and so on, all of which supports drawing skills. With the aid of these procedures, the artist can tell whether objects have a vertical, horizontal, or angled orientation in reality, and transfer these insights to the pastel drawing.

Duplicating a vertical, horizontal, or angle line is achieved by facing the subject matter and superimposing a straight edge on the contour, using the method described previously. Holding your extended arm, hand, and body rigidly in this orientation, pivot just with the feet to make your whole body rotate, then face the drawing surface at arm's length. "Lay" the comparison line on the surface, keeping your upper body parallel to the drawing surface. If done correctly, the drawn line will exactly duplicate the orientation of the same contour in the still life.

Demonstration: Still Life

"Carefully casual" is a term that might describe this composition, as it would a great many still lifes that we've all admired on museum and gallery walls. The objects seem to be accidentally placed, but actually are quite deliberately arranged to lend visual interest to mundane things that happened to be found on a table. For example, my focal point, the green bottle, is off-center because asymmetry is more compelling and realistic than a strictly centered and balanced layout. Another classic rule of good design, based on the triangle, is invoked here by leading the viewer's eye to three triangular points connected by color: the wine glass slightly behind and to the left of the bottle, a red napkin in the foreground, and an apple in the middle ground. This basic layout will be reinforced as the painting develops.

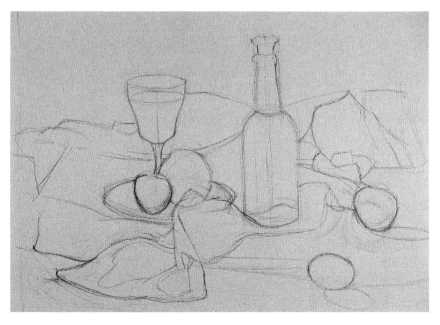

Step 1. Using a neutral-color pastel pencil, my first step is to diagram all the outlines, being careful to measure the proportion of each object accurately. It may take a while to complete this step, but proceed slowly and patiently. I used a view box to check my composition and position each element in relationship to the picture plane.

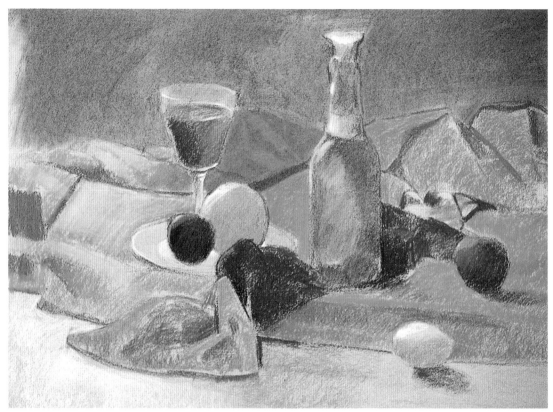

Step 2. All of my color foundations are established next. Don't be misled by the color complexity that's been set down already in the early step you see here. You should just start establishing the simple color base you visually experience while squinting. Don't worry about losing the original contour drawing. You'll still be able to see diagram lines at this stage; if not, they're easy to replace. Remember, you'll revise your beginning sketch over and over, and your many revisions will increase your insights.

Step 3. With a combination of revised drawing to reestablish correct contours and applying appropriate values and colors, I'm increasing the solidity of the mass area, and creating a sense of form. I've worked from dark to light, establishing the darker foundation first before applying lighter values later. I picked up reds, blues, and greens as I visually experienced them during renovation, starting with the harder pastels and working to the softer ones. I began with NuPastels then went to Girault and Holbein as needed.

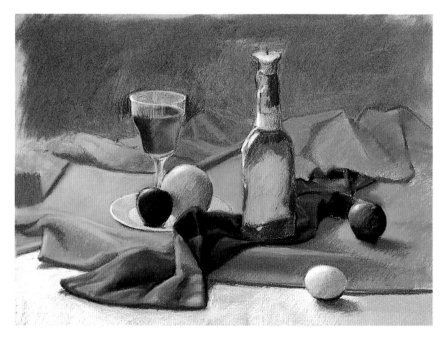

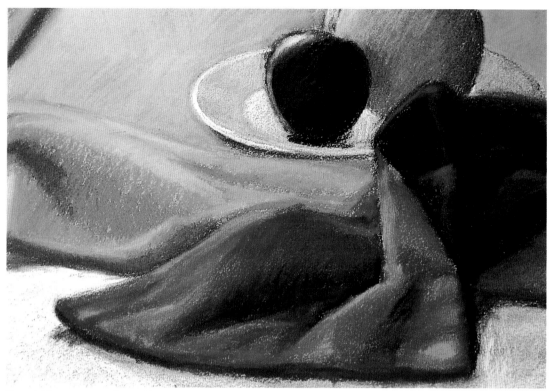

Step 4. The most complex and important area in a composition is its foreground. Working more on developing structure and color/value for this area, I'll leave the background only suggested, to make it recede. Even in this early step, I'm thinking of space and aerial perspective. I'm careful not to finish any section yet; this is still a general build-up and evaluation stage, and it's not important to be precise at this point. This general application will make improvements possible in future revisions. When you get to this step in your painting, don't be discouraged if you haven't yet achieved the look you want. The following revisions will take care of that.

This close-up of a foreground detail shows the fullness of my color application; notice that the grain of the paper no longer shows. This layering enables the structural components to be more evident, and the density of color increases the solidity of the area. This color coverage also produces an excellent base to build on.

Step 5. A close-up of the foreground shows how using the side of the pastel immediately encourages the paper's surface grain to become evident. This look is standard for the first application of pastel; additional applications will diminish the effect of grain.

Step 6. This close-up demonstrates how hatched lines over the first application of pastel help to increase the density of both value and color. The directional aspect of the hatching is visible in this example.

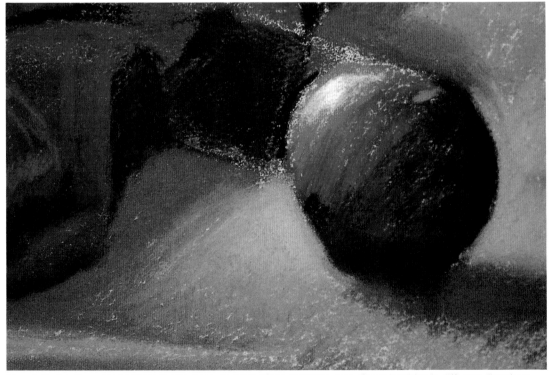

Step 7. Notice the cross-hatching in this close-up detail of the light-blue area. Cross-hatching in different directions will eventually eliminate the directional axis of the hatched lines and neutralize the surface area, allowing other functions to dominate. Evidence of grain may also be seen in the red areas.

Step 8. This close-up detail of the middle-ground red area shows the dominance of grain, and the inconclusive drapery structure. At this stage, the grain is visually stronger than anything else.

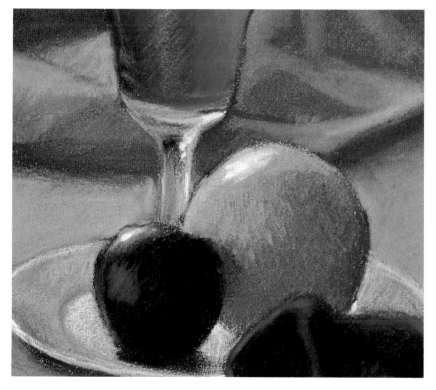

Step 9. Some basics stated earlier bear reiteration here, with this close-up detail providing an excellent example of the importance of geometric forms to still-life drawing. Note how the sphere and cylinder have been built up into three-dimensional forms through repeated and carefully considered color application. I started with shapes, revised to general solid forms, revised again to create specific solids, identifiable as wine glass, plum, and orange. The plate and folds of the cloth also began as general geometric outlines and gradually evolved into fully developed dimensional objects.

**STILL LIFE WITH
GREEN BOTTLE**
Pastel on paper, 18 × 24"
(45.7 × 60.9 cm).
Collection of the artist.

Step 10. The
foreground has been
clarified even more
and, by comparison,
the background is
diminished and
generalized in order
to create the illusion
of three-dimensional
space.

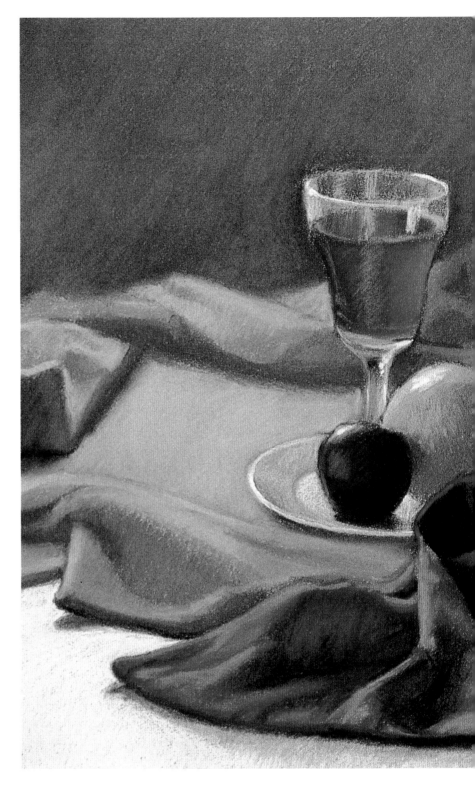

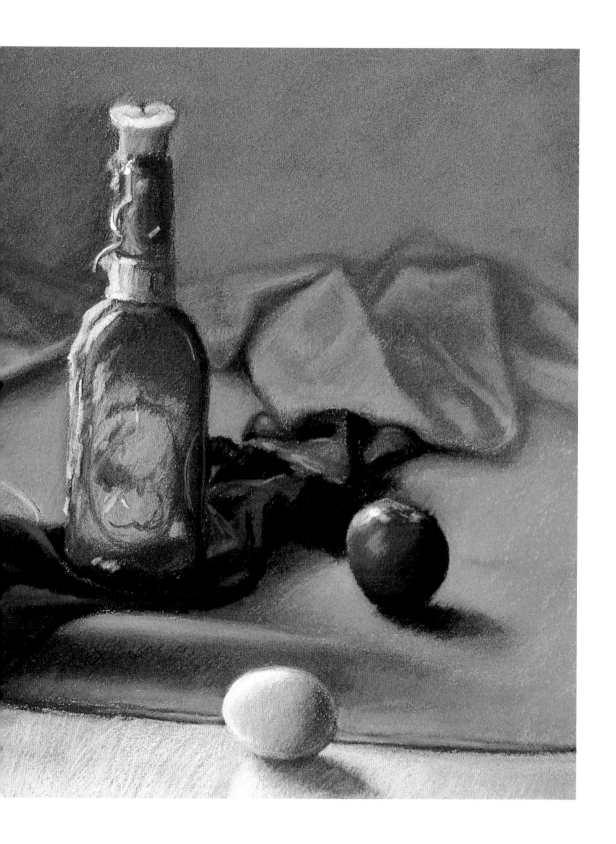

Landscape

Painting a landscape in *plein air* can be a simultaneously exciting, relaxing, and thoroughly engrossing experience. You're required to work fast, make decisions as to how light will flow in the composition, and stay with that plan regardless of the sun's shifting position. Claude Monet would often change painting surfaces right along with the movement of the sun to capture a precise moment in time. For less brilliant and/or ambitious artists, I recommend that you stay with the work you've begun and return to the scene at the same time of day under similar lighting conditions to maintain artistic integrity in finishing your painting.

When you set out to create a landscape in pastel, have a specific style and scheme in mind. I've seen too many artists flounder at their easels from not having planned ahead. When asked the question "What are you intending to paint?" they reply, "I don't know. I'm just trying to create a landscape." That's too vague. Instead, there should be specific goals to challenge and force the artist to work on skills and coordinate every part of the composition to serve the original intent and chosen style.

For serious beginners in landscape painting with pastel, a sophisticated choice is an Impressionistic style with a three-dimensional format. Envision the color scheme and specific lighting you'd like your painting to have. Then channel your creative energies toward that goal by proceeding in an orderly fashion, following the steps that are outlined in this chapter.

MARSHLAND
Pastel on paper, 24 × 18"
(60.9 × 45.7 cm).
Collection of Jean Blovits.

The many blues and greens in the foreground of this marsh find unity with similar middle-ground and background hues, but the intensity of those colors softens to suggest distance, just as the splashes of violet become pale tints of that color when they are worked gently into the background field of warm ocher.

Selecting the Subject

When you choose a setting, remember that you're telling a story— which will only be as good as its contents. The more you have to say, the better the story. So first of all, look around at nature and select the most interesting combinations of dominant and subordinate subject matter, colors, values, and textures to make up your landscape composition. This "cast of characters" in your story should be chosen to hold the viewer's interest.

CREATING A FRAME OF REFERENCE

How do you decide what to focus on in the setting? The eye takes in a panoramic view and it's often difficult to isolate extraneous elements without an excluding frame of reference. Artists will often use a mat-board viewfinder to find and frame the desired landscape composition. Everything else is obliterated by the mat border. There are two such devices:

Window Viewfinder

The beginner can create a viewfinder from an 8-×-10" black mat board. Cut a 3-×-5" window out of the middle of the mat board, using an X-Acto knife and a ruler. Black is chosen because it doesn't reflect any noticeable light back into the eye, making it easier to see the selected landscape image through the window opening.

Hold the viewer up in front of your face, moving it closer or farther away from your eye until you have settled on the ideal composition. You can also add black thread lines held with tape to divide the picture area into equal thirds both horizontally and vertically, or attach a clear piece of acetate over the opening with division lines drawn on it in ink. Dividing your composition into sections lets you sketch segments of the scene one by one to help maintain correct perspective and proportions.

When a landscape has buildings in it, it's particularly helpful to work with a segmented viewfinder. Looking at this example, you can be sure that if you section off your paper, sketch that roof line in the top two squares, place its slope in the center square, and continue to stay within the confines of each segment as you transfer information, your relative proportions will be correctly maintained.

FALL IN THE ORCHARDS
Pastel on paper, 18 × 24" (45.7 × 60.9 cm).
Collection of the artist.

The foreground shadows began as one dark shape, but see how many subtle color blends are there now. Near that cool shadow, the autumn colors nestled under dark tree trunks become even more fiery by contrast.

SPRUCE FLATS FALLS
Pastel on paper, 18 × 24" (45.7 × 60.9 cm).
Collection of the artist.

Working from dark to light was especially important here. That cascade of cool water was contrasted against a dark ground for its luminosity to be fully appreciated. Opposites of light and shade and a sense of depth were my goals.

Adjustable Viewfinder

Two L-shaped pieces of mat board, cut to about 8 × 12" each, can also be used as a scenic viewing device when you are working outdoors. This type of viewfinder is also particularly helpful when you're using a large photograph of a scene for reference purposes and need to scale it to your pastel composition. By using two mats instead of one, you have an adjustable window that can be arranged to form a smaller or larger rectangle corresponding proportionally to the dimensions of the painting being composed.

This scene makes an attractive photograph, but if I were to adapt it to a painting, I would alter its composition somewhat.

Using two L-shaped viewfinders allows me to shift borders, pulling them in and out until I find just the one that I think will work best. In this case, I'd say that the foreground grass area needs to be cut back considerably so that the focus moves immediately to the cows by bringing them nearer the viewer. The same adjustment on the right continues to improve the overall balance of all the pictorial elements.

Choosing Composition Elements

Having picked the scene you're going to paint, there are still many choices to make regarding elements within that setting. Referring to the painting below, here are some considerations that governed my selections.

- **Balance.** Individual objects within a composition have either physical or psychological strengths or weights that should be recognized when you are attempting to create a balanced composition. The largest trees and massed foliage are strong physical elements in *Linda's Jewel;* intense colors contribute psychological impact, affecting the mood of the painting.

- **Variety.** Variety creates personality in a painting. While the repetition of like objects can bring harmony to a painting, it can also bring monotony. Varying tree and leaf shapes as well as foreground growth and textures in my landscape (possibly more than actually existed in the setting being painted) helps sustain viewer interest.

- **Palette.** Instead of restricting myself to the cool, blue/green palette often seen in landscape art, I've taken advantage of the richness of the pastel medium and employed a full, jewel-like range of hues in this work.

LINDA'S JEWEL
Pastel on sandpaper,
11 × 14" (27.9 × 35.6 cm).
Collection of the artist.

When this many colors find their way into a landscape, balance in distributing them becomes especially important. The viewer's eye is immediately pulled to those high-value, vibrant reds on the left because of the lower-value contrasting environment, but by lowering their contrast in the center middle ground and muting them still more in the background on the right, the eye makes that connection and travels back into space. Using similar high-value, saturated blue greens on the same plane near the middle ground helps to group and unify them with the reds. A diagonal trail of greens from lower left to upper right establishes further color harmony. The pastel strokes and dabs most clearly defined are in the foreground wildflowers, grasses, and foliage. Detail is diminished with the middle ground and even more in the background growth, establishing a sense of depth and distance within the picture plane.

KEWEENAW
Pastel on paper, 18 × 24"
(45.7 × 60.9 cm).
Private collection.

The strong diagonal of this fallen tree trunk is like a pointing finger guiding the viewer into the painting, right toward the brightening sky, where streaks of pinkish white clouds pick up the diagonal sweep. The diversity of subject matter here offered me a good opportunity to exploit and exhibit the magic of the pastel medium in the way it allows the artist to depict a variety of textures. In this one setting, I found different woods of tree trunks; dry stone, wet stone; green grasses, strawlike grasses; verdant trees, barren trees; water and sky—all foils for my color excursion.

FALL STUDY
Pastel on paper, 11 × 14"
(27.9 × 35.6 cm). Private
collection.

While foliage is the dominant texture here, I had great variety to work with in the exquisite autumn palette that nature bestowed on this setting near my house. Dazzling oranges, reds, and yellows easily become garish if applied too flatly. Instead, layer the highest values of those colors in short strokes on top of a lower-value ground, letting some darker values show through for muting and contrast.

Keeping Things in Balance

LANDSCAPE COLORS

A variety of weight factors should be studied in relation to landscape colors. Brightness, contrast to environment, and abundance of a single hue must all be considered.

Proximity of hues must also be noted. A color possesses a higher balance (weight) factor when it's in extreme contrast to its surrounding colors. On the contrary, a color weak in contrast has a lower balance weight.

A large area of a single color contains a stronger balance factor when compared with a smaller opposing area. Therefore, a weak color, covering two thirds or three fourths of the composition, could balance with a smaller area of medium or strong color. Consider the weight, then consider the balance.

RESERVOIR
Pastel on paper, 10 × 13"
(25.4 × 33 cm). Private
collection.

The lower value of blues in the right-hand two-thirds of this painting is balanced by the higher-intensity, high-value yellows on the left, even though the yellows cover a much smaller area—only one-third of the composition. Bringing some of those yellow-greens into the blue area also builds color balance. In exchange, some of the blues that were layered earlier are allowed to come through subtly under yellows in the distant background and as shadow and reflection of the yellow-green foliage near the water.

VALUE

The range of values within a picture plane can also be a balance factor. An area containing numerous value changes is more provocative (weighty) than an area containing one value change.

Because of their position on the value scale, some colors reflect more light and are therefore stronger. Yellow, given its lightness and intensity, commands more balance weight than a darker blue or violet. Therefore, a smaller area of yellow could balance a larger area of blue.

TEXTURE

A textured or rough area commands more attention than smoother sections. An area containing a variety of textures would also command more balance weight than a part of your painting that contains only one texture.

DEE'S FIFTIETH
Pastel on paper,
14 × 18" (35.6 × 45.7 cm).
Collection of Dee Whiting.

To balance the beautiful blues and greens that dominate this scene, some warmer earth tones pop out of low brush above the middle ground, mirroring a brownish reflection in the pond both at that point and in the foreground. Even such small touches of complementary color can keep a mostly monochromatic painting from becoming too static.

ACTIVITY

An active area also demands more balance weight than a passive area. Direct, energetic pastel marks are examples of active strokes allowed to remain in their pure state as compared with a smooth area of transition where evidence of the artist's forceful marks has been eliminated.

DESCRIPTION AND DETAIL

Another example of balance concerns description and detail in one part of a landscape as compared with a lack of clear definition in other areas. Anything focused, clarified, and specific will demand more attention than objects only vaguely suggested.

NEAR CARRARA
Pastel on paper, 18 × 24"
(45.7 × 60.9 cm).
Private collection.

A little cart left behind on a hillside, dwarfed by its surroundings, is what first drew me to this scene. Then I realized what a strong value pattern there was in the contrast of lush, dark green trees against pale violet distant mountains streaked with marble—in Carrara, Italy, where Michelangelo quarried his marble. Exaggerating that contrast imparts increased depth perspective, emphasizing the great distance between foreground and background geography. When composing the scene on paper, by showing only a sliver of sky, I maintained the vast grandeur of the mountain as the primary focal point. Becoming an auxiliary point of interest, the little cart actually serves an important function, as the bright highlights falling on it counterbalance the marble and mist on the mountain.

Focusing Interest

Even a miniature work of art has a dominant point that draws the eye first. With a pastel landscape painting that's likely to have varied content, texture, color, light, and shadow all competing for attention, it's especially important to "direct traffic" so viewers know where to embark on their journey through your picture.

CENTER OF INTEREST

There should be a certain area in a landscape painting that commands our visual attention; our gaze is attracted there first. Not to be confused with the center of the composition, the center of interest can be placed anywhere in a painting. This attention grabber can be established by emphasizing many aspects of one area: line, color, value, and texture. An obvious example is one area of bright and active color surrounded by remaining dull and inactive elements of a composition. Of course, the dynamic area would always catch the viewer's eye first.

Since the Western eye normally reads from left to right, placement of the center of interest is usually, but not always, on the left side of a layout. An example of an eye lead-in would be a stream, path, or fence starting at the left edge and moving diagonally into the center of the composition.

SUBORDINATE POINTS OF INTEREST

After your eye has rested on and enjoyed the center of interest, it travels to secondary focal points. These have diminished contrast levels as compared with the primary focal point, but they complement and continue to add to the pictorial statement, helping to make the *whole* scene fascinating, rather than just its center of interest.

SPATIAL TRANSITIONS

Leading the eye from foreground to middle ground to background is another way to guide the viewer through the entire composition. These spatial transitions are created by the skillful diminishing of contrast in incremental degrees to create illusions of various positions within the picture plane. Background objects are connected to one another by their greatest and similar degree of contrast reduction as compared with middle ground and foreground objects. Constant overlapping, progressive reduction in size, and diminishing descriptive elements all contribute to the illusion of receding space.

SUNSWEPT
Pastel on paper,
12 × 18"
(30.5 × 45.7 cm).
Private collection.

A very dark background allows the shapes, colors, and textures of these scattered flowers to pop forward. The foreground warm salmon and cool violet tones are picked up in some of blossoms. The foreground shape is made purposely ambiguous to keep the flowers as focal point.

MORNING IN THE SMOKIES
Pastel on paper, 18 × 24"
(45.7 × 60.9 cm).
Private collection.

If you choose a setting such as this, in order to explore the contours and curves of a sprawling pasture and the majestic hills beyond, begin by squinting to block out everything but the value pattern of the rounded hills, shadows, and largest shapes on the landscape. The cows should be represented only as general shapes in the early stages of the pastel's development; their detailing comes later, in the final steps.

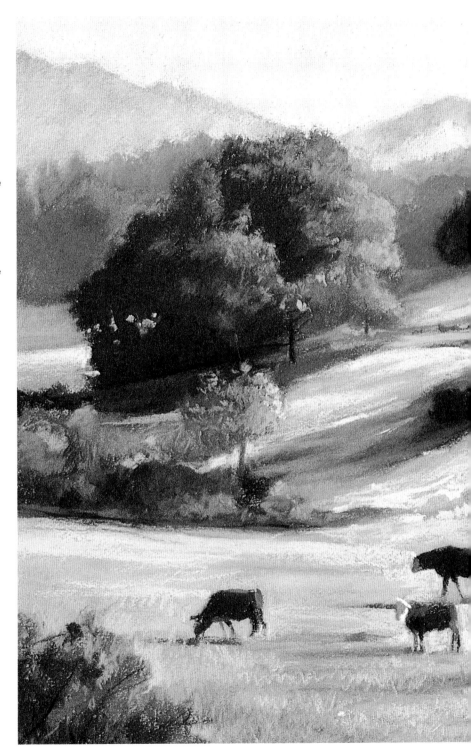

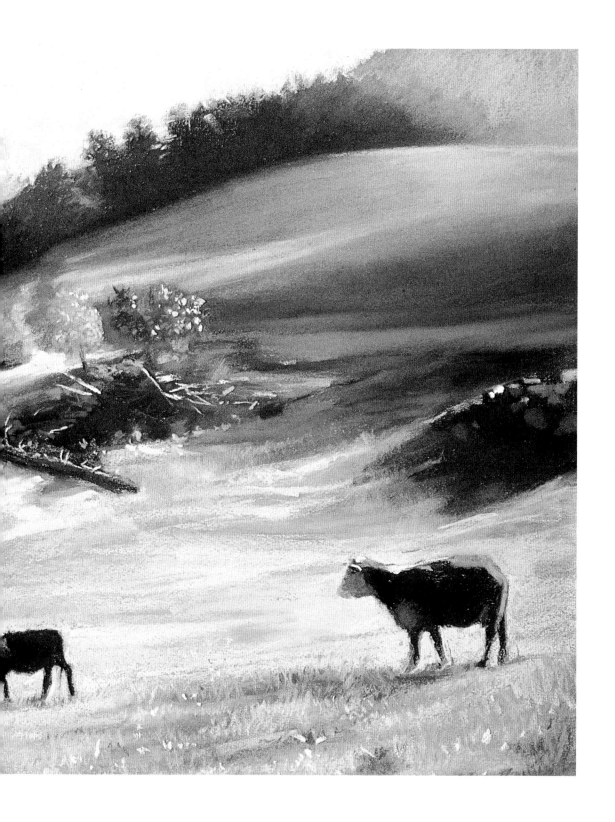

Working from Simple to Complex

As in a still life, landscape elements begin as simple geometric structures. But even before your first pastel mark is set on paper to begin your diagram, you should decide what your composition's format will be, a decision that affects all subsequent steps in building your pastel painting.

While my work is in a three-dimensional format, as shown and discussed in this book, let me briefly restate the distinction between it and the alternative two-dimensional format.

Two-Dimensional

When objects are given only height and width in a painting, with no attempt to suggest their depth or contour, they are painted in flat colors with minimal or no shading at all introduced. For example, a scene might include a tree that's a vertical stripe of solid brown topped by a green ball sitting next to a house depicted as a square, not a cube. This graphic, purely decorative look is a style you may want to try with pastel.

Three-Dimensional

When depth is added to height and width, a three-dimensional format emerges. Therefore, in a landscape, your painting technique would give volume, contour, depth, and perspective to the tree, the house, and other components in the scene. However, they would all begin life in your diagram as simple geometric forms that gradually develop into realistic entities, as was the case in our still-life study. So the tree that started as a cone begins looking like a pine tree as you give contour to its outline, along with light, shade, and shadow.

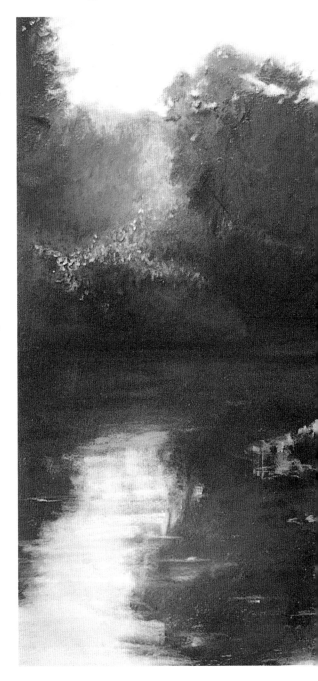

MORNING GLORY
Pastel on paper, 18 × 24"
(45.7 × 60.9 cm).
Private collection.

Morning light and long reflections produced wonderful abstract shapes on this quiet pond. Being made up of greens, blues, and violets, the palette is a cool one in color temperature. Although I used enough red in my violet blends to give them a measure of warmth, those smoothly blended, lightest violet hues are still cool enough to help make the most distant hills seem to recede. In the middle ground, I relied more on hatching and cross-hatching than on smooth blending, using shorter or longer strokes to describe grasses and underbrush. The lone swan, its reflection, and highlights on the water are all built up from color shapes to forms, then get their clarity and description only as a final step.

LIGHT DIRECTION

As you build from general to specific objects, light orientation will help define and unify your landscape. When a light source remains constant and has the same characteristics—diffused or concentrated light—it casts a harmonizing aura over the whole painting. Constant lighting assists the building of form, adds information to the growing content of your scene, and clarifies the characteristics of each and every object within it.

In terms of best times of day for *plein air* lighting, landscape artists generally prefer light with a low angle found in the early morning and late afternoon hours.

BERN RIVER
Pastel on paper,
17 × 23" (43.2 × 58.4 cm).
Private collection.

MORNING MIST
Pastel on paper,
19 × 25" (48.3 × 63.5 cm).
Private collection.

Above, lush foliage on the right, a craggy cliff on the left, a narrow winding river in between, and terraced hills straight ahead in the distance all converged, offering the rich material that inspired this pastel painting. With so many interesting elements competing for attention, it was especially important to find ways to unify separate areas of the scene into one cohesive picture. Using atmospheric perspective devices, I reduced and diminished characteristics to move the eye back to the low-contrast, almost monochromatic, background.

At right, the feature that made this scene so compelling was the contrast between dark trees in the foreground and the bright light of dawn breaking through the morning mist. The challenge was finding ways to sequence the reduction of subtle contrast from foreground to background. Instead of relying on saturated black, which should be avoided for such a silhouette, I used a broad array of middle-dark hues, including blues, reds, violets—at the deepest end of their value scales, then echoed some of those hues sequentially up to their highest values to tie in the pale violet trees in the distance and the color movements across the sky.

EVOLVING COLORS

Remember, every time you apply a stroke of pastel over another color, the stick picks up remnants of the first color. Wipe the pastel clean before applying additional strokes. On the other hand, if you wish to mix or dull colors, additional stroking, without in-between cleaning, will physically blend the colors together. Think about your desired result, and adjust your application technique accordingly.

MAKING ADJUSTMENTS

Before turning to the landscape demonstration that follows, it bears restating that a pastel painting should constantly evolve on its way to completion.

Keep this in mind and make changes whenever and wherever they're needed.

The professional pastelist accepts the reworking of paintings as a part of the learning process, which is a life-long pursuit in art. It's essential to ongoing training and development.

I hope that you will adopt that attitude. When you've completed a pastel painting, even before judging its merits, the most significant result should be the pleasure you've derived from the working process itself, and the value of newly acquired knowledge that will help with your next painting.

In other words: Keep challenging yourself to learn!

GRAND HAVEN TWILIGHT
Pastel on paper, 18 × 24"
(45.7 × 60.9 cm).
Collection of Jay Blovits.

The verticality of the lighthouse and smaller structure are deliberate counterpoints to the rhythm of horizontal color bands that make up this seascape. Grayed blues, creamy yellows, dusty pinks, and pale violets take turns streaking across the sky. Blues of various value, carefully layered, give the water its depth and rolling action. Note that while we see this surf as white, it is actually many blended light blues, only flecked with thin horizontal top strokes of white to suggest foam. The colors of the sky are repeated in the shoreline for balance purposes.

Demonstration: Landscape

This scene, which I photographed for reference in painting it, was selected because of the compositional balance, strong contrast between sunlight and shadow, distinct pattern, contrasts in color, value, texture, and content. I thought it was beautiful and was mesmerized by all the elements of nature presented at the same time.

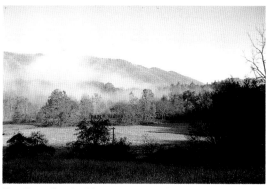

The Great Smoky Mountains, part of the Appalachians, are remarkable for their great variety of flora, which I was eager to interpret in pastel.

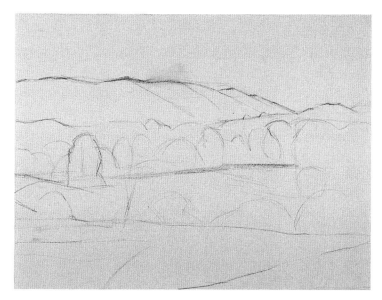

Step 1. For my beginning diagram I draw simple shapes to position all the large and medium-sized components in the picture plane, using a light outline in a neutral-colored pastel stick (NuPastel #283 Van Dyke Brown) sharpened to a point. These temporary outlines will be revised many times during this preliminary stage. Once general areas are established, I can evaluate shapes and placement and make composition corrections before going on to the next step.

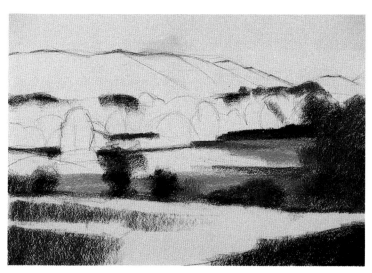

Step 2. To decide which colors I'll underpaint first, I squint my eyes while looking at the scene I've selected, then block in some of the dominant dark masses that I see, using the side of the pastel stick. Working from dark to light is standard procedure with opaque pastel colors. Squinting helps to eliminate specific components and details, thereby letting me view color and value in their simplest forms. In this underpainting stage, I make no attempt to create volume, light, or depth.

I recommend that you establish your primary color value a little darker than it actually is. This approach will produce a richer contrast basis for lighter revisions. The only exception to this rule is that the *very darkest* colors should be made slightly lighter to allow for the final use of black when revisions in deep shadows are made in later stages.

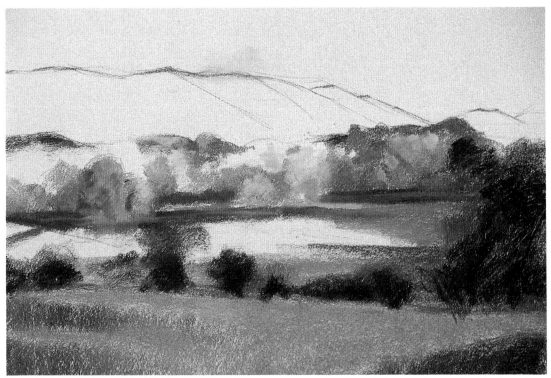

Step 3. Continuing my color block-in with smaller, more concentrated patches of pigment, I use a combination of hard and soft pastels, saving soft ones for last. I'm not worried that I might be choosing a "wrong" color. At this early stage, just try to get in the "ballpark" with colors; you can change them later as often as needed.

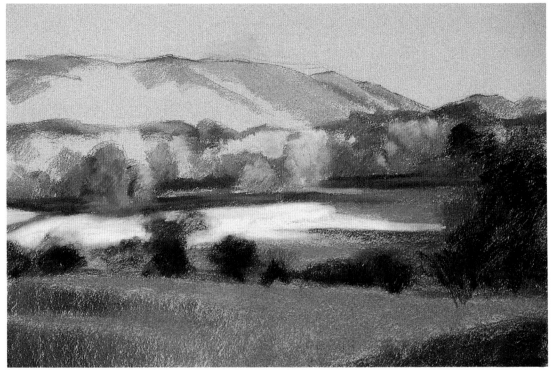

Step 4. Now working on all sections of the composition, I revise for good values, colors, and intensities while taking care to retain clear divisions between lights and darks. Almost 90 percent of the strokes were produced by using the flat sides of pastel sticks. Applying light strokes to "test" the calligraphy first, I continued to search for the right combination, making sure to keep the statement general. Specifics will happen in later stages.

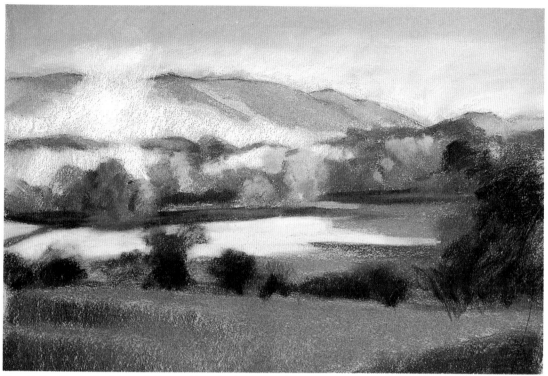

Step 5. Blocking in the lightest lights, at this point I make my first evaluation of overall color relationships. Whatever simple revisions need to be made, now is the time to make the foundation changes. I'm also refining the contours of individual shapes, solidifying the colors, and suppressing some of the brighter colors in the background by adding their respective complements to "gray" them down and make them recede.

Foreground detail. This close-up shows how I put down my darkest color values first before advancing to lighter ones. Strokes are varied to emulate nature.

Middle-ground detail. Lights applied over darks, effecting a misty look, are shown in this detail.

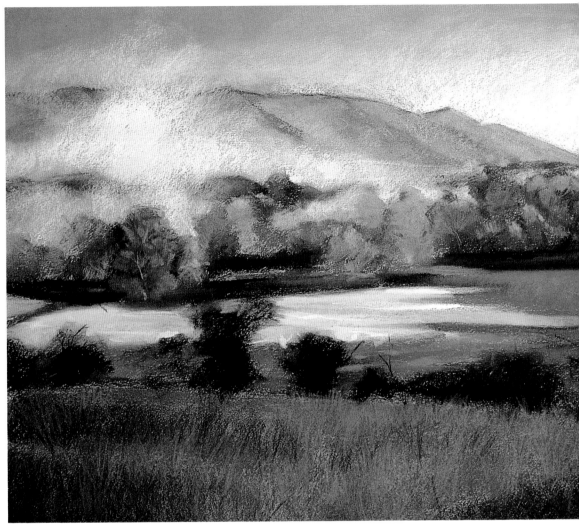

Step 6. There comes a time in every painting when you have to set the stage in one area in order to create a contrast for the remaining areas. I'm working on the background trying to soften and neutralize colors and subdue and eliminate contours to make these areas recede. At the same time, I'm trying to create the soft essence of the ephemeral cloud formations that typify the Smoky Mountains in the early morning light. Once I'm somewhat satisfied with this look, I'll start working on the transitions in the sunlit middle section before focusing on the intricacies of the foreground.

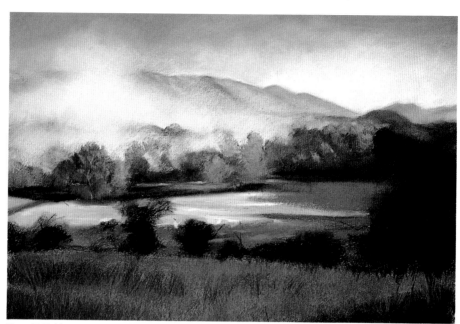

Step 7. Evident texture (rough) has a tendency to advance in a picture plane. I've rubbed the cloud and sky formations to eliminate such texture and create a solid base. I've also added more layers of color to the sky and clouds to reestablish the beauty of pastel rather than allowing the rubbed surface to be the visual one.

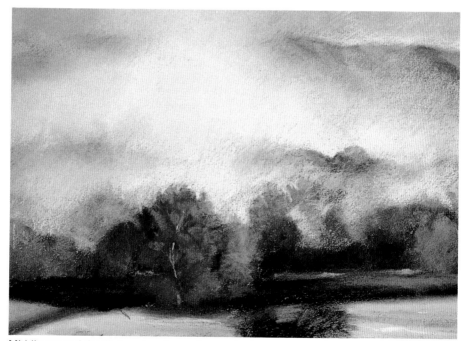

Middle-ground detail. I've placed many layers of color one on top of another attempting to find what I think is the best combination for this section. It's not unusual for me to revise an area four or five times until I'm satisfied. I wanted the colors to integrate and create the illusion of clouds and tree line. Wiping my pastel stick clean before applying each stroke helps to keep my color clean and sparkling.

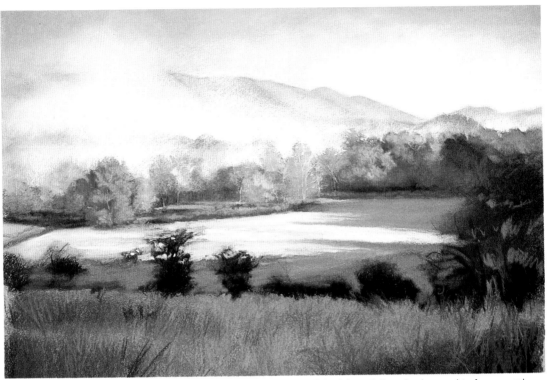

Step 8. After the pattern within the middle-ground shadow is established, I work from background to foreground, overlapping as the movement to the front continues. The directness of the final calligraphic strokes produces the pronounced contrast so necessary for establishing a foreground.

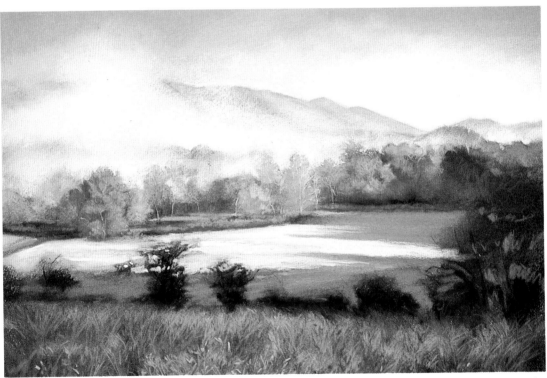

Step 9. Further development of the foreground is shown here. It was important to work on this area to gain control and a feeling for what I'm trying to create. As you can see, the depth in the composition is becoming quite obvious as I continue to work on spatial clues. Not yet finished, I wanted to see what everything looked like after the next stage of developing the trees and bushes overlapping the middle ground.

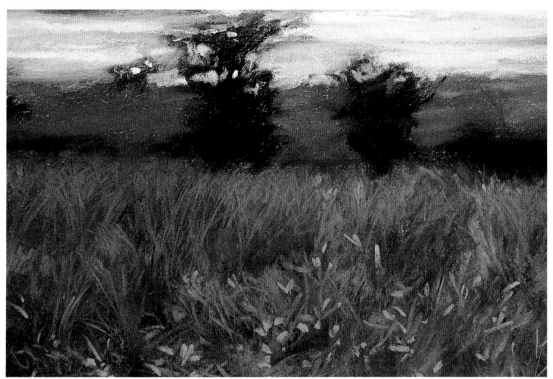

Foreground detail. In this close-up, observe the vitality produced by having many strokes integrated into the foreground foundation, while other strokes seem to sit on top.

Foreground detail. Bushes and trees were developed only after I was somewhat satisfied with the middle ground. These items are established as overlapping forms and made with calligraphic strokes. I want the marks to function with every stroke as I near completion of this landscape.

**EARLY MORNING IN
THE SMOKIES**
Pastel on paper, 18 × 24"
(45.7 × 60.9 cm).
Collection of the artist.

Step 10. At this
completion stage, I feel
I've captured both the
feeling of light and the
emotions I felt when
looking out the window
of the farmhouse from
which I first saw this
view. Technically, I
selected colors available
in my various sets to
approximate my artistic
vision. The last strokes
were made with the very
soft Schmincke pastels,
after which I applied a
coat of workable fixative.

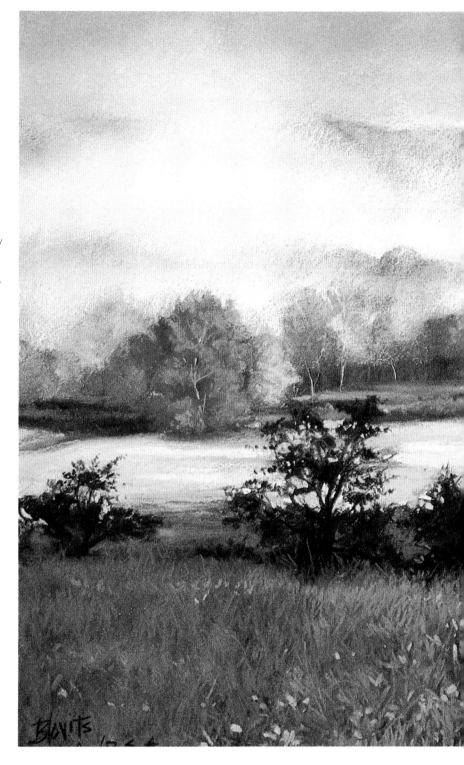

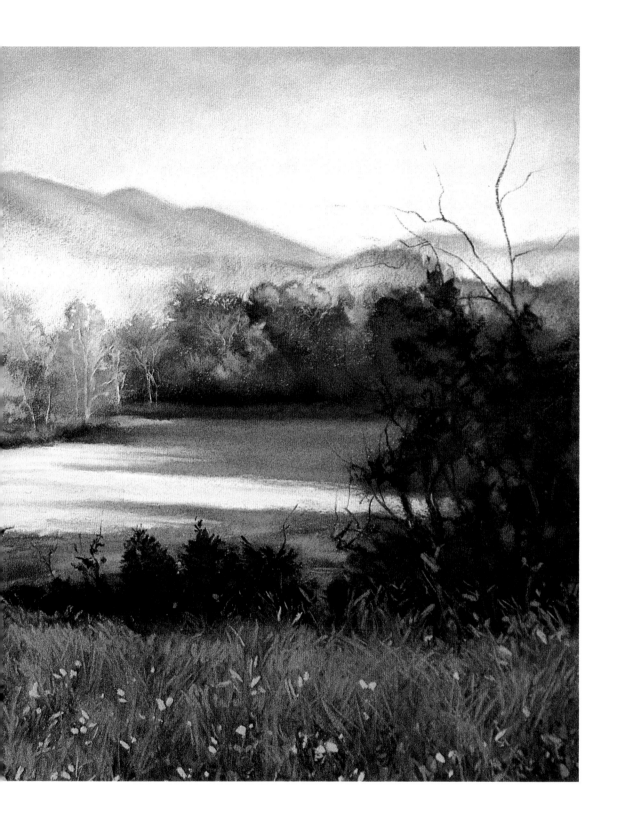

Figures and Portraits

Many artists, even those who have been painting for years, stay exclusively with still-life and landscape subjects. If asked why they never attempt figural work, the likely response is, "Oh, it's too hard to paint people."

If you share that mistaken impression, you won't be so intimidated by the human figure and face if you think of them as structures that can be built up in your pastel painting from simple shapes to dimensional forms in the same way that you would develop components in a still life or landscape. The technical approach is exactly the same: establishing the diagram, working from dark to light, from simple to complex; composing and positioning subject matter within the picture frame; building colors, values, textures, and forms.

This chapter discusses specifics of working with posed models, then presents two detailed demonstrations—one a head portrait, the other a seated figure. You may also want to try pastel studies not aimed at specific portrait likenesses but as genre paintings depicting people in scenes from daily life. You'll find that by studying and drawing the human figure, useful lessons will be learned about proportion and form that can be applied to all of your pastel paintings.

I CAN DO IT
Pastel on paper, 22 × 16"
(55.8 × 40.6 cm).
Private collection.

I created this painting for a local wheelchair association that sponsors sports events for participants with disabilities. In combination, the very free application of pastel, deliberately vague background, and loose, unfinished borders all serve to focus attention on the story being told— a young archer demonstrating her skills for the admiring group surrounding her.

Composing a Portrait

First, you need to choose your portrait boundaries. Will it be a close-up of the face alone? A bust portrait taking in head and shoulders? A figure cropped at the waist? Or a full figure—seated, reclining, or standing?

Whatever your choice, all portraits start by posing the model, and as you're doing that, determining what the boundaries will be. Rotating the model's position, from straight-on to profile, will provide you with many viewpoints. As you evaluate the model's characteristics for interest and aesthetics, decide how this particular portrait will be best served. A tight close-up on an especially expressive face may be a more compelling choice than a full-figure portrait of that subject. With another model, casualness might be the right note, conveyed by opening the composition to include a pair of graceful hands resting on the lap.

Decide whether the model is posed symmetrically or asymmetrically within the picture frame; asymmetrical balance is usually the best choice.

OUTSIDE CONTOUR

Now resolve what your outside contour will be. Will the portrait look more lively viewed straight on, turned slightly to one side or the other, or in profile? A figure facing straight forward may produce too static a silhouette, whereas seen in partial of full profile, the form may offer the artist broader artistic options. When viewing an outline, evaluate its edge characteristics abstractly, not for what it actually is. If it's too regulated, loosen it up, give it an unexpected twist to prevent it from becoming repetitive.

CREATE INTEREST THROUGH VARIETY

Plan some unusual touches. An adjustment in placing the model's arms or legs, or a tilt of the head can breathe life into what started out as a stiff pose. Try to costume portraits with attractive necklines, jewelry, patterns, and colors. If you don't like what's been provided by the subject, look for a better solution. Remember, you're composing. Don't accept everything as you find it. Take control of the situation.

Your portrait setting should also be under your control. If furniture is to be part of a portrait—such as a chair on which the model is seated—consider whether its contours help or hurt your composition. If a figure is shown in a more complex setting, with part of a room interior included, be careful not to upstage the sitter with too much emphasis on furnishings.

BALANCE

As with all pictorial presentations, portraits must be composed with balance carefully worked out. I think this consideration is so important that I hope you will bear with me while I reiterate some of the points I made about balance in earlier chapters on still life and landscape, and add others as they specifically relate to portraiture.

- Every element in a portrait possesses a balance weight. Therefore, every time something new is added to your composition, it shifts the balance, requiring a counterbalance.
- Look carefully at your model, checking many elements for balance. Slight adjustments, deletions, or additions in any of the following might shift the weight and change the balance in your portrait: color and shape of hair; color, style, and texture of clothing; direction of eyes; placement of hands; amount of skin showing; size and color of jewelry.
- Secondary objects and shapes, such as a table or window in the portrait setting, must be balanced against the subject figure.
- Also be sure that the figure area is balanced with areas of negative space: that is, spaces around your figure or between it and other objects in your portrait painting.

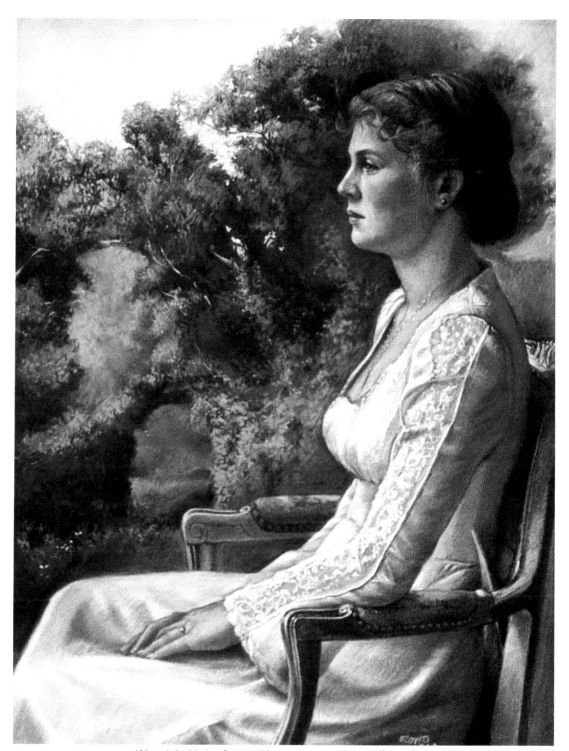

**PORTRAIT OF
DEIRDRE**
Pastel on paper, 24 × 18"
(60.9 × 45.7 cm).
Collection of Dennis
Campbell.

When I decided to feature this young woman's beautiful profile in a portrait with an outdoor setting, the dark tree became an important backdrop against which her fair skin and light dress would stand out. The decorative sleeve was carefully chosen to animate the lower part of the composition—the lace pattern being a good counterpoint to the "lacy" foliage in the upper left half.

Posing Sessions

For both professionals and beginners alike, it takes many sessions to develop and complete a pastel portrait. To make those sessions as smooth and productive as possible, with fullest harmony established between artist and model, here are some practical considerations.

MARKING THE POSE

It's helpful if the position of both the model and the artist's easel are precisely noted so that the setup will be the same at each sitting. The standard procedure is to use tape or chalk. I usually put masking-tape markers on the floor, model stand, light stand, and at the feet of my easel.

Even though you're a serious beginner working in pastel, if you do not yet have a studio or other space reserved exclusively for painting, and are unable to tape an area that's used for other purposes between painting sessions, take careful measurements and record where you and your model were positioned, then pace off and replicate that setup each time you work with your model. Having that reference will save hours of trial and error as you shift position trying to correct your painting. A Polaroid picture of the model, taken at the conclusion of the previous session from your precise painting eye level and angle of view, is another helpful aid.

If you're working on a figure or portrait painting out of doors in an area where you cannot use tape, chalk, or paint on the ground or grass, heavy stones always make good markers.

POSING TIME

Don't overtax your model with long posing sessions. Each twenty to thirty minutes of holding a pose should be followed by a ten-minute break. In fact, *you* may need a break just as often as the model does. The total posing time shouldn't exceed three hours, and if either you or your model tires before that, end sooner.

Schedule posing sessions on consecutive days, if possible. You'll be able to sustain your concentration better that way. Also, resist the urge to work on the painting when the model isn't posing. Unless you're very experienced, the changes you make will be invented rather than derivative.

Working with models isn't always easy. Be prepared to be flexible, to change procedures as needed to accommodate the one who's posing for you. Especially if your subject is not a professional model, you'll have to explain the importance of holding a position without moving—which is really hard for some people to do. So, if you see your model shifting back and forth just when you're working on the torso, focus on something less affected by that movement—perhaps hair or clothing folds—until the model is steadier again, perhaps right after a rest period. Then resume painting in that torso area.

Portrait Lighting

Consistent lighting, whether natural or artificial, is critically important when you are doing life portraits. Lighting should be placed (or the model positioned) at an angle that describes the form completely. For the portrait artist, so-called Rembrandt lighting is preferred, where the light source comes from in front and above, and slightly off to one side. This illumination seems to contribute most to our understanding of human facial features. Be careful not to place the most descriptive features in shadow, or to make the shadows more important than the form. You'll be able to tell by slowly moving the light source (or model) and watching its effect on the subject's features as changes occur.

LIGHT SOURCE AND DIRECTION

Decide whether you're using sunlight or artificial light, and whether the light will be strong and direct, or soft and diffused. Play with the light or model position until you're satisfied with the look. The type and intensity of light impacts the statement. A soft, diffused light establishes a subdued aura; a strong, concentrated light creates bright and shadowed areas, suggesting drama and mystery.

Natural Light

If you are using natural light, north light has the best degree of constancy, with the least degree of change throughout the day. Working at the same time of day helps to keep the light situation as close as possible to the preceding day's. Using the same type of light source to illuminate the model, pastel palette, and pastel surface eliminates problems in reading and selecting colors accurately.

For portrait work, it's often impractical to depend on the weather for consistent lighting patterns from day to day. But if you do use natural light as your source, schedule model sessions for the same hours on consecutive days. Try to arrange having your light come from one window and above eye level. Eliminate conflicting light sources by blocking any other windows in the room. Revolve the model chair or stand to find the light that produces the best structural forms, and then mark that position with tape. Stop working when you notice an obvious failing of light in late afternoon.

Artificial Light

An incandescent spotlight gives the artist the most control, allowing easy duplication of light at any time of the day or night, day in and day out. Be careful not to place the bulb too close to the model for a couple of reasons: You won't be able to see value changes on the light side, so necessary for producing form; and the intensity of the light might make the model uncomfortable, which will cause squinting. A plastic diffusion screen attached to the outside of the reflector, or a piece of gauze draped over the reflector, will soften the light and make posing more bearable for the model. Allow enough air space between the reflector hood and/or gauze to prevent both from burning.

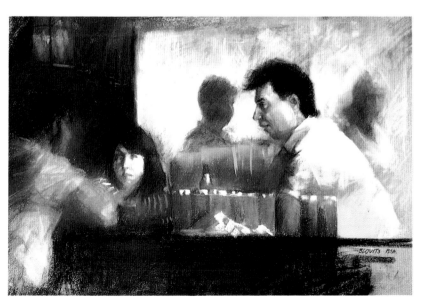

YOOPER DIALOGUE
Pastel on paper, 18 × 24"
(45.7 × 60.9 cm).
Collection of the artist.

Candid portraits recorded in public places often begin with rough sketches that the artist makes unbeknownst to the subjects featured. If you can't photograph for future reference, make detailed notes about light and shadow patterns and color values. When you approach a scene such as this casual moment at a bar, aim for general resemblance, not exact likeness, then develop your sketch into pastel back in your studio.

You may need to use a reflector, such as a white sheet, piece of Fome-Core, or aluminum-covered board to provide reflective light to a too-dark shadow side. Take your time and play around with the light source and position until you're completely pleased with the results. Once satisfied, keep this as your light position for the remainder of the portrait.

My favorite incandescent lighting setup includes two Smith-Victor photographic stands (ten or twelve foot) with light reflectors (ten or twelve inch). I use a blue floodlight called North Light. Additional lamps of the same type illuminate both my pastel palette and drawing surface to equalize light on model, pastel palette, and paper. Normally, I use one main bulb for the major form-building function, and a fill light to produce reflected light. The ratio of main light to secondary is usually three to one (300-watt main light to 100-watt fill light), placed at equal distances from the model. Sometimes my main and fill lights are of equal wattage, but I place the fill light three times farther away from the model as the main light. Experiment with lighting ratio and distance to achieve your desired effect. With practice, you'll soon be able see the ratio with the naked eye.

JACK DAGLEY
Pastel on paper, 39 × 27"
(99 × 68.6 cm).
Collection of the artist.

I began this portrait with an underpainting to establish color and value in the background, which then served as a comparison basis for all revisions during the creation of the figure. Using hatching and cross-hatching strokes, I laid in darkest hues first on the clothing. Then developing the head, with light coming in from the left, I worked on the darker, shadow side first, using NuPastel, Rembrandt, Girault, and Yarka pastels. After continuing to revise and correct the face, I developed other areas, centering my color corrections on the hands, shoes, pants, and chair, giving the chair its gold trim. The necktie was then adjusted to the level of the finished vest and suit. Background colors were modified to provide enough contrast to foreground detail. The proportions of the face were adjusted again because of constant buildup and color revision, and at that point, I added the eyeglasses.

PORTRAIT STUDY, JULIE
Pastel on paper, 24 × 18"
(60.9 × 45.7 cm).
Collection of the artist.

Instead of looking directly at the viewer, this sitter seems to gaze into the distance, which lends a bit of a dreamlike quality to her portrait. The cool turquoise blouse and sweater find their complement color in muted orange background tones, against which Julie's dark hair stands out.

Portrait Color and Texture

Working from dark to light is the same procedure as detailed in previous chapters; the approach doesn't change just because it's a portrait. Textural effects produced both by paper and pastel strokes are also options the artist exercises in depicting people, just as in landscapes and still lifes. But here are some specific additional suggestions relating to portraiture.

COLOR

Your portrait palette is important for reasons of unity, contrast, intensity, and coordination. A dark background might be selected to contrast against light skin for dramatic effect; a light background would provide contrast to show off the contours of dark hair; a dull background color would emphasize bright clothing. Psychological implications also come into play. For example, color associations elicit different viewer response to a red blouse versus a light-blue one; black versus white; multiple, garish colors versus a monochromatic, muted palette.

When it comes to flesh tones, the beginner is apt to think they are derived from one color only. Not so. Painting flesh tones with one color would be both boring and inaccurate. You can observe many

MITCH
Pastel on paper, 24 × 18"
(60.9 × 45.7 cm).
Collection of the artist.

This model's clear blue eyes seemed to demand a background to match. Blues are again echoed in many of the shadows of his white jacket and trousers, and are even worked into his coal-black hair. Using warm red blends liberally to describe Mitch's ruddy complexion and full lips created a vibrant contrast to the cool blues and whites. This relaxed pose, with the head turned slightly to a three-quarter view, rather than placed more formally straight forward, seemed an appropriate choice. The model's casual wardrobe reinforces that informality.

subtle hues in skin tones that cover the full spectrum. Don't hesitate to put down a blue, green, violet, or orange if you think you see it. Variations within one color are present—and not always blatantly obvious. A red-violet isn't necessarily viewed as a full-intensity color. The color mixture may be neutralized (complementary color mixed with it), grayed (black and white added), and tinted (combined with white). When you've identified a color, put it down. The multiple hatching, cross-hatching, and revision colors will all coordinate together as a flesh tone later on.

TEXTURE

The surface of the board or paper you work on will produce a certain texture immediately, and you must decide whether that texture should remain to enhance the portrait you're painting, or be suppressed. As noted earlier, rough texture may compete for visual dominance. In pastel portraits particularly, facial features are usually better expressed with smooth blending. I recommend creating texture when needed, perhaps for clothing, jewelry, a plant, or other prop in the picture or background at a later stage when it can be controlled rather than fought with during beginning phases of a portrait.

Just as in other kinds of pastel paintings, when you do introduce texture in a figure composition, you should build it up using a variety of techniques, which will create more interest than relying on one only.

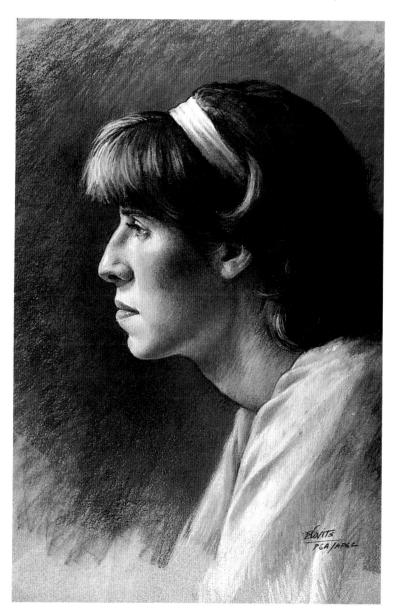

MARIANNE
Pastel on paper, 24 × 18"
(60.9 × 45.7 cm).
Collection of the artist.

A strong profile like Marianne's, reminiscent of those seen on ancient Roman coins, called for intense light directed on the front of her face to bring maximum attention to its interesting contours. The lighted side of her strawberry-blond hair and salmon-colored blouse share hues and values. The side of her face in shadow picks up some of those hues in reflected light coming from the blouse. For contrast to all those warm tones, I created a dense, dark background of violet with a lot of blue in it. This also served to emphasize the light on the face.

Figure Placement Within the Picture Plane

Establishing a figure within the picture plane is always a matter of balance and deciding what the image includes and excludes. Let me amplify my earlier instruction on this point by introducing you to a hypothetical device that I use to help with figure placement.

THE "GLASS BOX"
After deciding on your model's specific pose, try visualizing the outside contour of that figure inside a picture frame. One way is to imagine you have a glass box with movable sides, top, and bottom. Enclose the posed figure in this pretend box, then try a series of imaginary shifts of the box sides. Move vertical sides inward until they touch the left and right edges of the figure; shift the top down until it touches the head or hair, and the bottom up until it includes or excludes desired elements.

This enclosing procedure can also be accomplished with a viewfinder made of black mat board, as described in the previous chapter. Holding the viewfinder in front of your eye, position the posed model in the viewfinder opening and adjust the distance nearer or farther away from your eye to accomplish the enclosure described above. The edges of the black window mat touch the tops and sides of the figure contour. This establishes where key elements—head and shoulders—are located within this enclosure: to the left or right of center, above or below middle.

The window image also informs the artist as to size, shape, and location of negative spaces. An arm posed with the hand resting on the hip surrounds an open area between the arm and the side of the body—the negative space. That area can be a provocative shape with interesting connotations and edges (therefore having a visual weight) and just as important, balance-wise, as anything else in the composition.

FIGURE SIZE
A figure that's smaller than life size is easier to keep in proportion than larger ones. To determine the proportion of the figure to the picture plane, a simple rule of thumb is to equalize the total area of positive and negative shapes. Another placement hint is to leave enough space above the head (equal to the space from hairline to top of head) for the head to "breathe."

The identical concerns exist for a head portrait as for a figure composition. Don't crowd the edge of the picture frame by setting the neck or bottom of a V-neck blouse or shirt on the picture frame's edge or border. Allow for enough room to see those shapes without infringement by a mat or frame opening. Evaluate all shapes in an abstract sense for balance, interest, relationships, and aesthetics. Look at the work of the great masters of portraiture for guidance.

FIGURE CUT-OFF POINTS
Be careful not to crop a figure at the joints (elbow, knee, middle of the hands) or at any other visually awkward part of the body. Midpoints between joints are usually acceptable. The hands, typically left out by amateur artists, are very expressive and can contribute much to a portrait. If you're inexperienced at drawing hands, be assured that the more you practice, the better you'll become at portraying them.

JULIANNE
Pastel on paper,
24 × 19" (60.9 × 48.3 cm).
Collection of Gary Willcock.

At right, this model's gracious smile certainly commands the viewer's attention first. (Notice that the teeth, though white, have shadow and volume—but avoid some beginners' temptation to define each tooth individually.) Because the smile would be a strong focal point, it was important to establish a secondary point of interest in the lower part of the composition, which the elaborately patterned bodice accomplished.

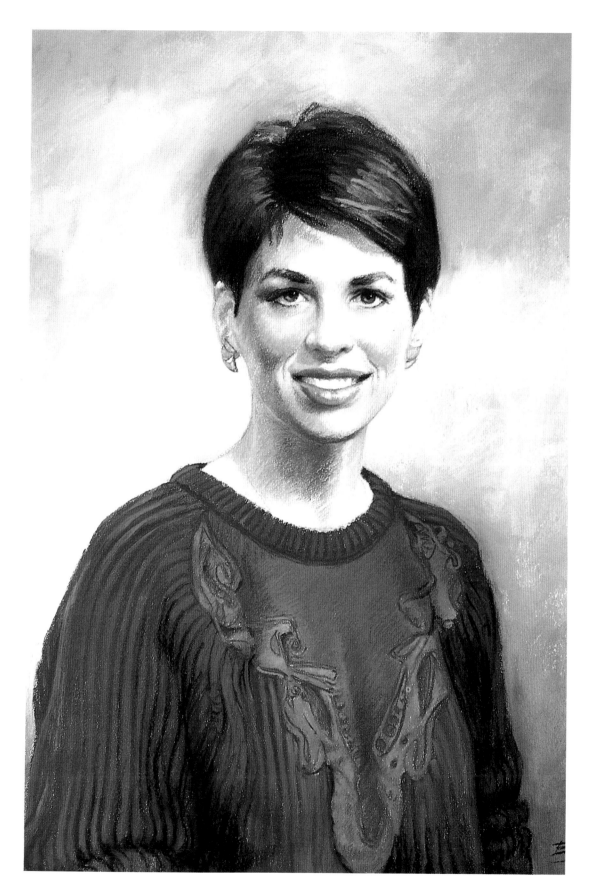

Painting the Human Form

Relating the figure's structural parts to basic geometric forms is the next order of business. An arm is likened to a cylinder, a head to an egg, and so on. Begin individual facial features in the same way; the eye is an orb, the nose a triangle. As you take these simple sketched shapes through progressive building stages, layering and blending pastel colors, the basic geometric forms should never be forgotten. Too often the beginning artist gets caught up in surface details that don't coordinate with the structural foundation.

SHAPE

Retain correct shapes through frequent measuring and adjusting. As with objects in a still life, the shapes in a portrait should remain in proportion to one another, as based on the first shape you measure as the standard for all that follows.

Important areas not to ignore are the shapes, dimensions, and configurations between the eyes, ears, nose, and mouth. These shapes are often overlooked as being unimportant, and when not measured, they get out of proportion. Every shape proportion should have the same degree of importance. The configuration of the shape must be accurate as well. Think of it as that one puzzle piece out of twenty choices in a thousand-piece puzzle that looks almost exactly the same but is the only one that will fit because it is the perfect configuration. That's the degree of accuracy to strive for.

FORM

Once all the shapes have been completed accurately in perfect proportion, the evolution to form can take place. During this revision, the proportion may be shifted and requires continual rechecking until completion. Yes, each form should still be a derivative of one of the simple geometric forms—sphere, cone, cylinder, cube, pyramid—before evolving them to recognizable anatomical forms.

While I've just used the word *perfect* in referring to proportion, an objective every serious beginner should look toward, in fairness to readers who are less experienced with figure art, I would say, don't put undue stress on yourself trying to make things "perfect." For your development as an artist, treat every portrait as a learning exercise. When you're practicing, it's all right to make mistakes. One of the beauties of pastel painting is how correctable it is. Just continue to make those corrections, and your knowledge and facility will grow. This freedom to learn isn't possible when you're worried about "messing up" the drawing.

The easiest way to practice is simply to create figure studies for trial-and-error purposes. Once you achieve a modicum of success with competent figure drawings (working with pastels or simply with pencil), it's time to attempt to create likeness in a head portrait. How successful you are is really not important. It's what you learn in the process that is!

Getting a Likeness

Developing a head portrait parallels every step used in developing a figure composition, with one exception: the goal of a pastel portrait is to capture a likeness of the subject. Don't mistakenly think that some people have a natural talent for drawing resemblance and others don't. Portraiture skills can be developed. Here are some tips.

MEASURE, PROPORTION, SHAPE, PLANES

- Proportion measurements are most important. Measure individual facial features in relation to the overall size of the face and head.
- Each facial feature starts out as a flat shape: height and width only. Find that height-to-width ratio.

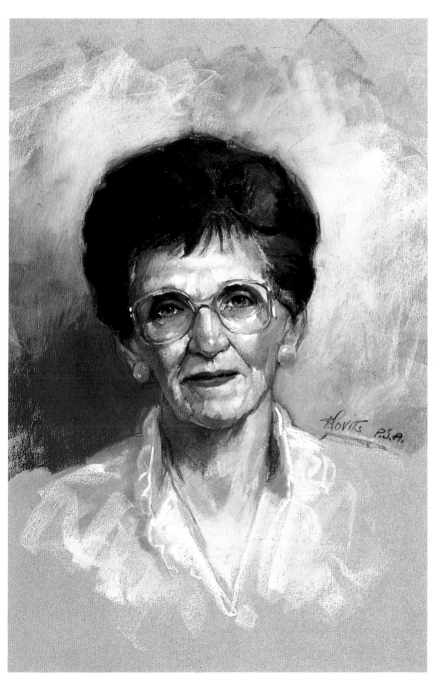

IOLA DEVER
Pastel on paper, 25 × 19"
(63.5 × 48.3 cm).
Collection of the artist.

By closing in for a tight head portrait with minimal inclusion of wardrobe, I was able to maximize focus on this woman's warm, expressive face. Notice how many contours and planes have been built up on the face. Dark blends were established first on the shadowed side and on the neck; middle-value reds and browns were distributed on the forehead, nose, and chin; the lightest hues and highlights were placed last. The skin tones were revised many times as features were redrawn to accord with corrected measurements that I continued to make throughout the creation of the portrait.

- Measure and establish one feature first; then relate all others to it.
- Just how do facial features relate to one another? Perhaps the width of the subject's mouth is equal to the length of her nose? Or the nose is shorter? Find that out by measuring, using the viewing devices described earlier.
- When measured accurately, each shape becomes the norm comparison for all other future shapes created in drawing the head.
- Remember to measure areas between features as well. How much space is there between upper lip and base of nose? (That vertical groove is called the philtrum. Take a good look at it; it varies in distinctiveness from person to person.) What's the distance from eyebrow to hairline? Accept those measurements as being accurate regardless of how strange the diagrammed shape may look. It's only the beginning shape, not the form.
- Likeness grows as shapes evolve into forms with gradations of pastel color, light, and shadow. The preliminary triangle becomes a nose as you keenly observe—*and continue to measure*—the slope from bridge to tip, the space between nostrils, and all the planes and contours of the mass that is becoming a nose, which you will soon recognize in your pastel painting as belonging to your particular model.
- Even a featureless area such as a forehead takes on its own characteristics as it transforms from the simple square it was at first.
- If you're accurate in all your shape measurements, then you're well on your way to producing a likeness. If measurements are incorrect, your pastel painting won't look exactly like the sitter no matter what you do. Learn to be careful in observation and measurement. Don't take anything for granted.

DISTINCTIVE CHARACTERISTICS

Each of us has certain facial traits that are unique to ourselves. Most people also have a "best" or "worst" feature—stronger or weaker aspects to their face. Capitalize on the pluses and play down the negatives in a head portrait.

Intense eyes are often heightened by depicting them looking straight out at the viewer. But suppose you want to direct primary attention in your painting to a full, beautiful smile that's very characteristic of the model's personality? In that case, the sitter's eyes might be better looking off to the side, rather than at the viewer, thereby making the big smile the focal point. Distinctive hair color or shape can be given extra focus by contrasting it against an opposite color-value background or paper color to show it off.

As for playing down "worst" features, artists often exercise artistic license to make a portrait more complimentary or pleasing to the sitter. As creator and interpreter, you are in complete control of the image on your paper and are not bound by absolute realism in your portrayal. Chances are, the sitter will be gratified by the favorable adjustments you make.

VARIETY

Whether you're working on a head portrait or a figural composition, variety can lend excitement to your pastel painting. The word *variety* here refers to using different descriptive pastel marks to state textural distinctions: Hair strokes should flow like hair; jewelry should shine; fabrics should possess pertinent characteristics that help identify their textures. Variations excite the eye and hold the viewer's interest. That's one of the reasons rubbing over the entire pastel surface is frowned upon. All the colors are dull; all the descriptive marks are suppressed. It's monotonous!

Portrait Background

The selection of paper color or the preparation of a surface color is important to portrait work. Sometimes the paper or background color is chosen as a contrast to emphasize the figure's skin color or clothing. Conversely, a color that's similar to the model's clothing color might be selected so that if it shows through subsequent color applications, it coordinates or blends in. Whatever your choice, there are two basic background treatments to consider: simple or complex.

SIMPLE BACKGROUND

Many times, paper color is left unpainted in portraits. Sometimes the artist matches paper and applied background color (behind the figure) so that they are nearly one and the same. A dark color will emphasize a light area; a light color will emphasize a dark area. Bright colors are normally avoided because they demand too much attention and usually overwhelm lower-intensity colors. Neutral colors are universal and can be used for anything.

For either figure or head portraits, a subdued and simple background allows the artist during the creation process and the viewer later on to concentrate on the poser. It's easier for the artist to select and paint pastel colors when surface and background colors match both in hue and value.

You can purchase inexpensive material to use as a background drape. Hang the fabric behind the model to eliminate any disturbing elements in the studio or other space in which you're working.

The color choice for a background has many ramifications. It can be chosen to harmonize or contrast with colors of the model's hair, skin, or clothing. It might show off the interesting contour of hair or a provocative profile. On the contrary, background color may be selected to blend with the model's hair-color value so as to emphasize the face, not the hair.

COMPLEX BACKGROUND

Sometimes a patterned or accessorized background is chosen specifically for its design qualities as important narrative elements in the portrait. Among the many painters who have used this format is the nineteenth-century Viennese artist Gustav Klimt, whose paintings offer exciting examples.

But a complex background can present problems for the beginning pastelist. Stronger elements and contrasts compete for dominance and may simply overwhelm the portrait. If so, the artist must find a way to modify complex background elements if the portrait is to remain the focal point. Suggested solutions are painting the background out of focus; lowering the value and intensity of chosen colors; or simply making the background an abstraction. No matter what, unless deliberate stylization and decorative narrative is intended, the background should stay back to facilitate enhancement of the portrait subject.

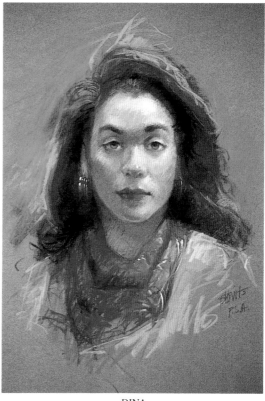

DINA
Pastel on paper, 24 × 18" (60.9 × 45.7 cm).
Collection of the artist.

Sometimes an unfinished background such as this spotlights a portrait to advantage. The blues behind the head connected to the blues and greens of the bodice become a cool oval frame around the chestnut hair and warm skin tones. Strong chiaroscuro creates a big contrast between the deepest shadows and bright highlights on the model's face.

Developing a Portrait

Now that we've reviewed composing a portrait, posing the model, painting the human form, getting a likeness, and making background choices, the following summary of generalities and reminders should be a helpful reference before we proceed to the step-by-step demonstrations.

BEGINNING DIAGRAM

Creating a figure or head portrait requires a correct proportion ratio among all elements. Start out with the same diagram procedure used for other subject matter. Pay strict attention to the proportions of each shape and proportion relationships of all shapes to the whole torso.

Placement of the head shape is a crucial balance consideration at the outset. Remember the discussion of using the imaginary glass box enclosure to position the subject in the picture plane. Also realize mistakes are common, and all can be corrected during the revision stages. Just try to do your best. Your drawing should go through many changes before it's finally completed.

Starting a first portrait is often discouraging for the beginner, and too often, the tendency is to give up. Don't! I assure you that this same insecurity is experienced by the professional. The only difference is that the pro knows from repeated experience that with perseverance, the diagram of the model will finally materialize. It may take two or three hours to complete the drawing with all the measurements and attention to accuracy required, but it's both worthwhile and necessary.

REVISIONS

The importance of continual revision in pastel portraiture cannot be overstated. Changes are a result of critical observations. Do you remember that analogy to puzzle pieces that I made earlier in another context? Here, too, finding that one piece that looks like many others but is the only one with the precise configuration to fit into the empty space is what I mean by critical evaluation.

Don't take for granted anything you've previously created; scrutinize everything for accuracy. As you change one area, its neighboring areas have also shifted and may need adjustments as well.

PORTRAIT EVOLUTION AND DETAIL

As with other subject matter, portraits evolve from general shapes to dimensional forms to specific figures with personal traits and unique facial features. When you think you're near completion and begin adding detail, beware of a common trap. Since many artists, especially beginners, resist revising an area once its details have been placed, be sure that you save detail for last, only after correct shape proportions, edges, forms, structures, colors, values, and textures have all been evolved to completion.

MELINDA
Pastel on paper,
24 × 18" (60.9 × 45.7 cm).
Collection of the artist.

At right, to emphasize this model's crowning glory, of which she is rightfully proud, I placed her forward in the picture plane with lots of pale background above her exceptionally full, rich, reddish brown hair. A simple white blouse serves to keep the focus on the head and face. The faint glimmer of gold earrings and a gold and stone necklace provide decorative touches.

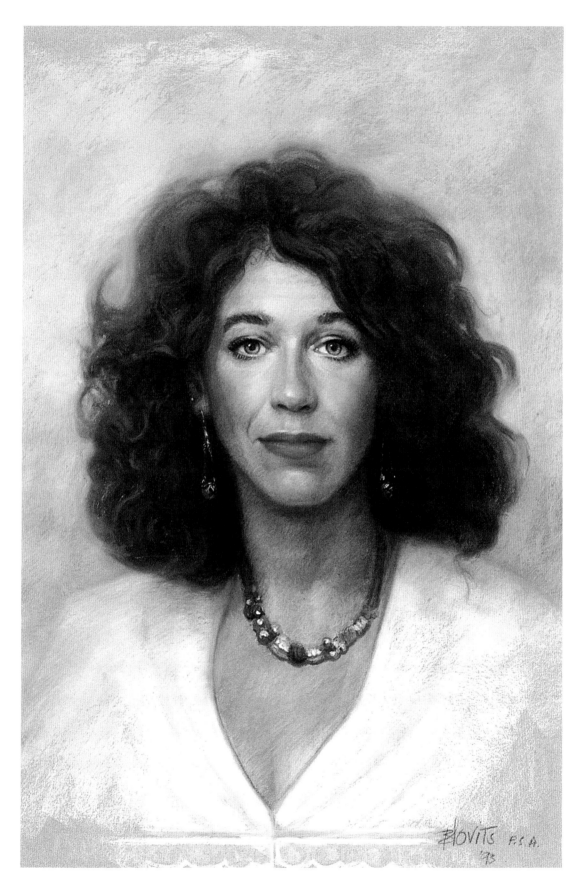

Photography for Portrait Reference

I have urged in earlier chapters that you work from life, not photos, as much as possible. For portraits, it's especially important to have the living, breathing, three-dimensional model in front of you rather than a flat photo to copy.

However, there are times when the only choice is photography—a memorial portrait of the deceased being the most usual circumstance. Babies and small children cannot be counted on to pose, and sometimes a commission to paint a portrait of a very busy executive can be carried out only by using photographs of the subject. In all other cases where a model is available for posing sessions, photographs may still be useful for follow-up reference between sessions.

CLIENT'S PHOTOGRAPHS

One of the biggest nightmares for the professional portrait artist is when the client says, "I have photos—work from these," and then hands you amateurish pictures that require a magnifying glass and vivid imagination to see. Unless you're very skilled and have an excellent background in anatomy and life drawing, bad photos will throw you off and be useless as reference. Even if you're doing a portrait of a family member or friend in a nonprofessional context, don't handicap yourself by accepting impossible photographs. Take your own instead. After all, you're an artist, not a magician!

REPHOTOGRAPHING

If you must work with an existing photograph, have it enlarged. Even with an old picture, a copy negative and enlargement can be made by a commercial photography shop. It won't be as good as the original negative, but it helps to make a less-than-ideal situation a little better.

WHEN TO SAY NO

Serious beginners in pastel painting sometimes find themselves caught up prematurely in the commercial scene and start thinking "profit" before having all the requisite skills, experience, and know-how to work professionally, particularly in portraiture. Because pastel portraits have such wide appeal, if you are sought out by clients before you feel ready, don't let the economics of securing a commission cloud your judgment. Especially if a photograph presented by the client is impossible to work from, and beyond your beginning skills, say so and refuse the commission. Otherwise, you'll suffer anxiety, frustration, and discouragement from not being able to complete the portrait to your own satisfaction, and suffer the ultimate ignominy of having the painting rejected by the client.

Demonstration: Figure Portrait

My neighbor, Gerry, agreed to pose. Deciding that I wanted to establish an informal, narrative portrait, showing a little slice of life rather than a formal pose, I arranged this "candid" moment by having Gerry sit at a table and become engrossed in reading. Natural north light flooding through a window directed excellent bright illumination on one side of the sitter, with good contrasting shadows on the other side. In addition to the book, a few casual props on the table lend color to the setting, as does the wood of the tabletop itself. Gerry's shirt, with its insignia patch on the sleeve, also engages the viewer's attention and interest.

Step 1. After setting up the pose, I took this photograph of Gerry to establish a reference in case I needed it to augment sitting sessions.

Step 2. I begin by establishing a loose diagram and immediately start blocking in the background. Notice the grain of the initial layer of dark-gray color on the window molding. I used a soft tissue to rub this hue into a solid and passive environment tone behind the figure, where I wanted to concentrate most of my early efforts. The first colors I lay in on the shadow side for flesh tones are siennas and reds; on the light side, yellow ochre, scarlet, gold ochre; for hair, burnt and raw umber.

Step 3. Establishing more of my overall palette, I have my first sense of what the color scheme looks like. I've concentrated more on the figure to establish a color base and structure for the skin areas. The shadowed side of the face and arms are based on layering of a few colors: Indian red, raw umber, mars violet; the highlights on the forehead owe their brightness to blends of warmer colors with a higher value, such as light oxide red and gold ochre.

Step 4. Now I've restated everything in and around the figure. The three-dimensional forms of torso and head are established, as well as the structure of the shirt. Notice how the shirt is whitest near the window and lower in value on the opposite side. While the actual shirt was white and I refer to it as such, you can see that many blues were used to express whiteness. The tabletop wood tones were painted with ochres and umbers.

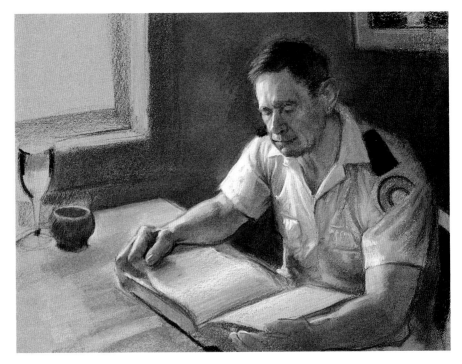

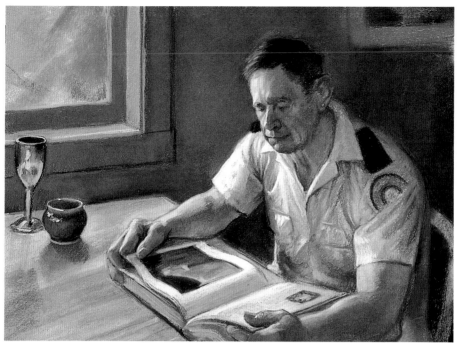

Step 5. Working on subordinate areas, I'm up to my third revision of this painting. I've now concentrated more on areas subordinate to the model's head and torso: book, hands, table, still life, and window. Developing these enables me to evaluate the whole painting in full color, which in turn provides me with direction for the balance of the composition. At this point, I'm not sure how far I'll carry the development of the outside landscape seen through the window, but suggesting some color and content there is preferable to the sharp, solid square of white light seen in the photograph of this pose shown at the start of the demonstration.

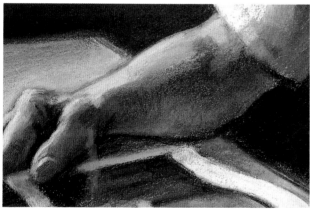

Step 6. Above, this close-up of an arm reveals the variety and directions of pastel marks. Colors used for the shadow and reflective light areas are subdued and less intense, complying with the requirements of the halftones, core, and reflected light for the illusion of volume. Observe how gray, violet, and blue are used for the "white" page in shadow.

Step 7. At right, in this close-up of the goblet and little vase, notice the indication of light source, volume, and the variety of marks created by hatching, cross-hatching, and application of different pressures. The bright marks on the highlight side were made with a heavy pressure. Reflected light and shadow colors have been added to the vase, and I've reworked color and structure throughout. The goblet has more identity and structure than before, and note that red reflections balance reds emanating from the book page.

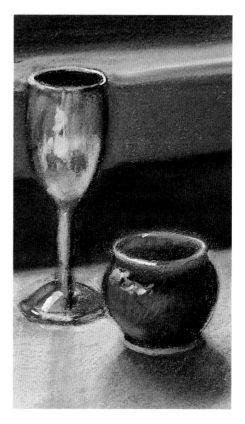

Step 8. The different strokes displayed in this close-up were achieved by applying varied pressure to the many pastel sticks I used. Some strokes are still evident, while others have been intermixed and blended together with other colors in a delicate manner. Overall, there is a sense of the light, volume, and depth that have been important considerations throughout this painting.

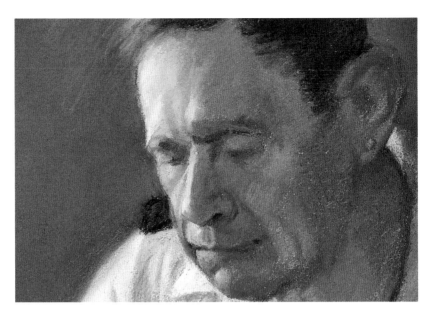

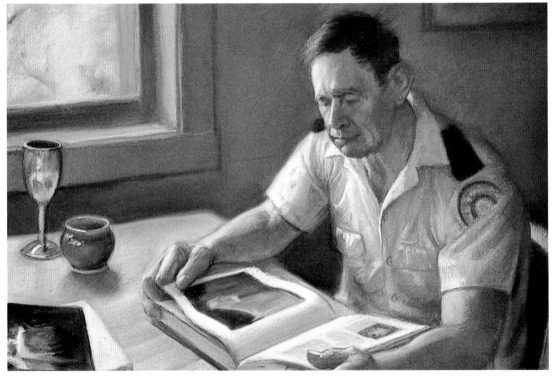

GERRY READING
Pastel on paper, 18 × 24"
(45.7 × 60.9 cm).
Collection of the artist.

Step 9. Before completing this portrait, I went back and reworked everything, then decided to let it rest for a while until I figured out what was missing. I did have a feeling that the weight was a little too heavy on the right side and needed a counterbalance on the left. Having time to reflect before finishing up the artwork is good. If my gut reaction says there's something in need of revision, there usually is. (Take a lesson from this example, and don't be too hasty to pop your pastel into a frame.)

I finally decided to add a couple of books on the left side for the sake of balance and interest. If you refer back to Step 5, you'll see that the light table area on the lower left side didn't contain the physical or optical weight necessary to balance off the right side. I also softened a few edges here and there and reworked both arms as well.

Demonstration: Head Portrait

When I asked my fiancée to pose for this portrait, my decision to place her against a solid dark background came quickly, as I knew it would emphasize her lovely golden hair. Choosing a dark-value dress keeps the focus on Linda's head, yet the bodice offered enough pattern detail to enliven color in the lower half of the composition without detracting from the upper focal point.

Step 2. With Linda posing, my easel in the foreground shows the vantage point from which I look directly at her. My drawing surface is situated underneath a special fluorescent bulb rated at 6250° Kelvin (a combination of two GE chroma 50 for 5000° K, and two GE Chroma 75 for 7500° K). This is the type of light I work under when not using daylight. The bulbs simulate daylight.

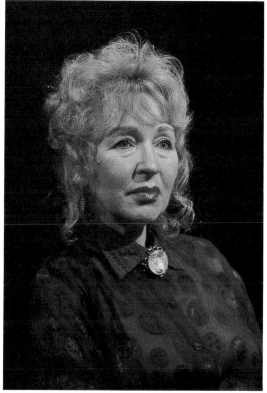

Step 1. This photograph, which I took for reference, shows Linda posing under three incandescent lights: a 50-watt halogen spotlight as the main light; a 30-watt fill light on the left; and a 15-watt hair light.

I described the formal pose I wanted to create, and Linda selected a beautiful blouse for the sitting. Once she was in the chair, I rotated the model stand, carefully selecting the lighting effects I wanted. Lifting the back of her collar and adding the brooch seemed good counterbalances to the face. Her upswept hairstyle contributed to the regality of the pose. Since her blouse was a dark wine red, I initially decided to use black for the background. Later on, I felt a need to add deep blue-violet for an enlivening contrast.

Step 3. I begin by placing diagram lines using a sharpened NuPastel stick #253 cocoa brown, carefully measuring the height and width ratio. The darker lines are made with #223 burnt umber. The head shape was placed slightly to the left side to compensate and balance with the body shape that is slightly to the right of center. It's important to remember that the first lines won't show any clues as what the final diagram will look like.

Step 4. Following the procedure of working dark to light, I block in the background with Holbein black pastel and also use a Holbein #9 pastel blending brush to eliminate the grain and convert the area into a solid flat value. I then go over it with another layer of Holbein black. A solid area is easier to make visible changes on than a rough, grainy area. I choose Holbein black because it's not as black as NuPastel black, which I reserve for later, when I'll want a darker dark.

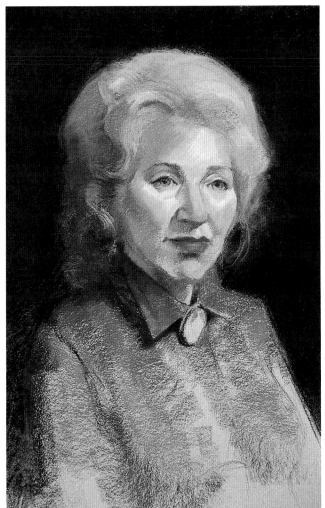

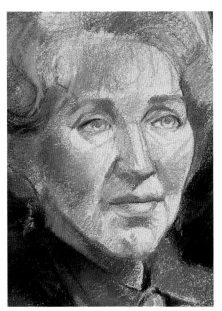

Step 5. This close-up detail shows the first application of darker colors to the head and collar area. These are simply foundation colors. Many revisions will happen along the way as the drawing is developed. Notice that diagram lines are still visible.

Step 6. Underpainting the torso starts with a foundation of color and value. This first all-over color application is probably the most frustrating stage for the beginner, because the expectation is so high. But keep in mind that this is just the beginning stage, and should look like it. The image will improve as you've had the chance to make numerous drawing corrections and color revisions.

When adding red to a gray surface (the color of the paper), the gray takes on the hue of the red's complement, the green cast seen on the bodice. Middle ochres and reds are used on the light side; deeper sienna, umbers, and violets are used on the shadow side. The colors are "grayed" down so as not to compete with the intensity of the face colors. When I continue to develop the blouse, colors such as red-violet light, red-violet deep, purple madder, and madder-lake deep will all be employed, lightened on the light side, deepened on the shadow side.

Step 7. This head close-up reveals how many different colors contribute to building up realistic flesh tones. But the model's particular complexion should always be paramount in guiding your choices. Linda's rosy coloring dictates liberal use of reds not only on cheeks but in eye sockets, forehead, chin—and particularly since she's wearing red, her clothing reflection also adds to the rosy glow I'm building.

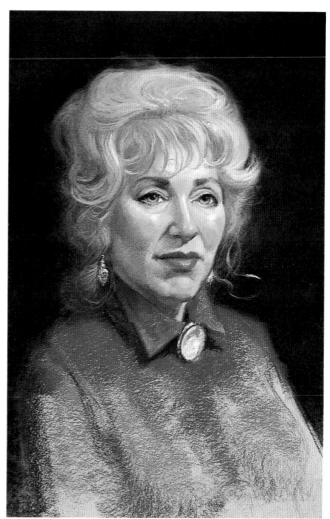

Step 9. Specific characteristics that help identify the subject have now been introduced. The shape of the eyelid, the corners of the mouth, the set of the brows—I've worked hard to observe all of these facial traits carefully and set them down faithfully. Do the same with your portrait. Try not to generalize. Search for what makes your subject look different.

Step 8. Notice how the pastel strokes have integrated to form the whole structure, not the parts. A close-up detail focusing on eye, nose, and lip area shows how much smooth blending has been done since the previous step. Still, in this close-up, I've discovered that the iris shape requires a slight adjustment in contour. Highlights—a speck of white to the eye pupil, a fine line and dot of white to the nose—are then added to lend radiance, as do some bright gold flecks on the hair coming down over the forehead.

Step 10. I've reworked the face and put more concentration on the hair. All the relationships of color and value have changed and adjusted accordingly. I'm still questioning whether my colors, values, and intensities are correct or not. The shape configurations are scrutinized over and over.

When creating hair, I try to concentrate on developing this area at one sitting, as the hairdo will probably be slightly different the next time the model poses. Anything that's subject to change from sitting to sitting should be finished in one session, if possible.

Step 11. Notice in this close-up detail how I've rubbed the outside contour of the hair to make it softer, indistinct, and recessive. Sure, when I look at Linda's hair at the edge, my eyes focus and I can see everything clearly. However, my intention is to make the hair form look three-dimensional, and therefore I paint what I want the viewer to see—an indication of spatial recession.

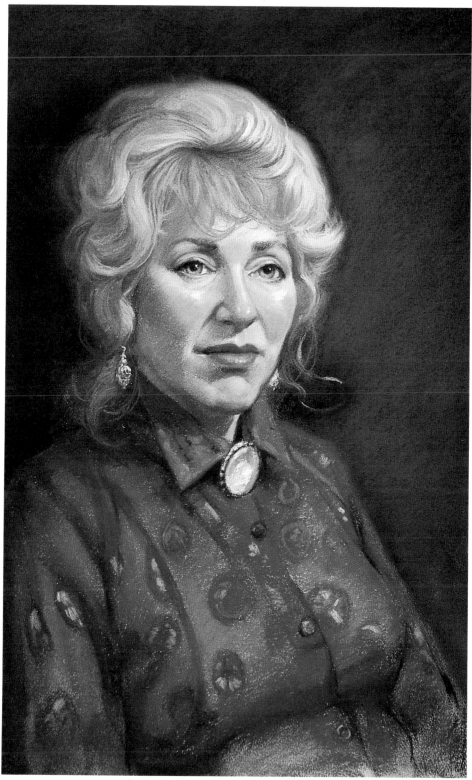

LINDA
Pastel on paper, 24 × 18"
(60.9 × 45.7 cm).
Collection of the artist.

Step12. With final details added—refinements on the cameo pin at the collar, the earrings, more tiny touches of highlights—I concentrate on defining and finishing the pattern on the blouse. While its wine color is a dark value, note that subtle pale accents within the pattern pick up and coordinate with the light values of skin and hair.

Index